IMPOSTERS

Imposters

All photographs © 2007 by James Knoblauch except where otherwise noted. The Writer's Words, Imposter interviews and Dave Markey interview © 2007 by Shawna Kenney. From through the Photographer's Lens and Jim's Blurbs (pages 20, 30, 34, 38, 40, 42, 58, 62, 82) © 2007 by James Knoblauch. Endpaper illustrations © by Ben Woodward.

Instigator: Roger Gastman
Design & production: Christopher D Salyers
Editing: Buzz Poole
Typefaces used: Headline, Yanone Kaffeesatz

Library of Congress Control Number:
2007930510

Printed and bound at the National Press, Hashemite Kingdom of Jordan

10 9 8 7 6 5 4 3 2 1 First edition

This edition © 2007
Mark Batty Publisher
36 West 37th Street, Penthouse
New York, NY 10018
www.markbattypublisher.com

ISBN-10: 0-9790486-8-0
ISBN-13: 978-0-9790486-8-5

Distributed outside North America by:
Thames & Hudson Ltd
181A High Holborn
London WC1V 7QX
United Kingdom
Tel: 00 44 20 7845 5000
Fax: 00 44 20 7845 5055
www.thameshudson.co.uk

MARK BATTY PUBLISHER
NEW YORK CITY

IMPOSTERS

PHOTOGRAPHS & BLURBS BY JAMES KNOBLAUCH COMMENTARY BY SHAWNA KENNEY

FROM ONE EDITOR TO ANOTHER, AND ON TO YOU THE READER

In the world of periodicals and book publishing, editors are the ones that determine whether or not a concept is worth pursuing and eventually publishing, for the publication in question. Needless to say, lots of ideas get bounced off editors, some of them good, a few of them great, many of them mediocre and others just straight up laughable. Timing often plays into it—what might be a sound idea for an article or new title simply may not fit with the theme of an issue, or into the seasonal "front-list" in publisher-speak. Of course, editors are subjective beings, charged with the responsibility of choosing and crafting these themes and editorial directions, ideally, into a program that is seamless, so readers never question the presence of an article or a book. An editor has succeeded when readers pick up a new issue or title and think, *Yeah, of course this would come from these folks!*

Here at MBP, lots of good ideas get tossed over the proverbial transom, though they must endure the rigors of the aforementioned realities. One trial that several of these must suffer through is the "magazine article" test. On more than one occasion, someone has pitched a great looking, topical and edgy book. It catches our attention. We sit around and talk about it. It comes down to this, however: Would the book-to-be really make for a good book, or would it be more successful as a magazine piece? Especially in the realm of illustrated books, the power and effectiveness of the visual, its greatest virtue really, can be its succinctness. What may make for a few excellent two-page spreads may very well make for a dull book.

When Roger Gastman first proposed the idea for this book to me, he did it with an issue of *Swindle*, which also included articles about Irish political murals, Los Angeles taco trucks, the life and death of Eazy-E, Jewish reggae artists and some real-life ghost-busters. Thrown into the mix with these eclectic and arresting topics, it was clear that James Knoblauch's intimate, humorous and telling photographs, along with Shawna Kenney's interviews of these Imposters, made for an entertaining magazine piece. But would they hold people's interest as a book, even as a short book? How many out-of-work actors and glorified vagrants dressed up as iconic Hollywood creations do people want to look at and read about?

Soon, the MBP brain trust received more photographs and interviews that had been collected during the process of putting the article together and we knew we had a worthwhile book on our hands. Knoblauch had met and spoke with all of these Imposters, went to their homes and met their friends and families, establishing contacts for Kenney so she could interview them. The result of the connections that these two established is apparent in the images and the personal tidbits about these people, both when they are in character and out of character, or in the case of Elvis, unable to break character.

In learning about how these people live and work and what inspires them to spend long, hot days along Hollywood Boulevard snuggling up against tourists, cultural indicators become evident, in a way that goes well beyond the Imposters. Yes, this book is about people impersonating characters for a buck. But it is also about our culture of celebrity, a culture of living vicariously and virtually, of striving for something pretty damn unattainable, and how people will pay to approximate the desire and walk happily away with a photograph of them and their favorite fictional character.

As as we got further along into production on this book, more and more markers ensured that we had indeed made the right decision. Knoblauch let us know about renowned filmmaker David Markey's feature-length documentary about the Imposters, only he calls them Reinactors; MySpace and YouTube footage of fights between the Imposters circulated widely; some of the Imposters appeared regularly on Jimmy Kimmel's talk show; criminal charges filed against Elmo and Chewbacca making national news. It was clear that these costumed enigmas commanded cultural traction, attracting media attention from all over the world, seemingly for no other reason than their proximity to celebrities, albeit a false proximity.

In having worked with Gastman, Kenney and Knoblauch for several months, updating and fleshing out the original *Swindle* piece, their initial investment of time and effort could only yield something larger than a magazine article. It is doubtless what Gastman thought when he assigned the piece, and judging by the lasting impressions that the Imposters made on Kenney and Knoblauch, the both of them realize that this was more than just an article. The fact is, it is more than just a book of funny photographs of strange people, but short of spending hours upon hours along Hollywood Boulevard watching the Imposters in action and then following them home, this is the only way you can find out what this is all about.

Buzz Poole
Managing Editor, Mark Batty Publisher
New York City, 2007

JAMES KNOBLAUCH: FROM THROUGH THE PHOTOGRAPHER'S LENS

When I first saw the Imposters, I loved how they fit the Hollywood landscape. Their costumes were faded and they blended in with the blue sky, white concrete and dirty air. I loved seeing a character such as Gandalf ordering a cup of coffee at Starbucks.

These characters work on Hollywood Boulevard, posing for pictures with tourists in the hope of receiving a tip. For the most part, the Imposters are actors who prefer the idea of working the street over working in a restaurant. It's sort of like a freelancing Donald Duck or Mickey Mouse.

I began photographing these characters in 2001 outside of Grauman's Chinese Theater on Hollywood Boulevard with a white backdrop taped behind them. I liked the performance aspect of the shoot but felt it would be more interesting to photograph the characters in their apartments. Hams and exhibitionists, many of the characters were cool with the idea. So began my adventures.

I found that the characters fell into one of three living categories. Like most people, the first group lived in an apartment or house and viewed their work on the Boulevard as an ordinary 9 to 5 job. These folks seemed to have an affinity toward the character they portrayed and invested more time into their costume and presentation. They made the most money on a consistent basis.

The second group seemed younger and lived in a squatter-type environment. They usually lived with other characters and had heard of the Boulevard opportunity through their roommates. They didn't seem to make much money and usually stopped hustling after a month or so.

The third group of characters I found to be a bit bizarre. They mostly came from out-of-state and somehow realized that the Boulevard would be a good way to make some quick cash. Many characters lived in long-term hotel rooms with other characters. I was surprised to find how committed these people were to the job and I believe you can still find many of them there.

In light of this mixed bag of serious, aspiring actors and your run-of-the-mill vagabonds, a hierarchy and code of conduct do exist. On the Boulevard, there are two "regulators." Superman and Batman and have been working the Boulevard the longest and are the most committed. These two have had their ups and downs, however. I learned about the rift between the two when I photographed Batman. The conversation turned quickly to him being arrested, no thanks to Superman. Superman claims to own the world's largest collection of Superman memorabilia, something he takes very seriously. One day, Batman agreed to help move Superman's

collectables into a new apartment. During the moving process, a rogue driver had parked in such a way as to block Superman's truck. The situation heated up when Batman confronted the driver, who proceeded to call the police. The man reported that Batman had threatened his life. Realizing how everything was headed into a downward spiral, Superman told the officer that he didn't know Batman, had never even seen him before. Superman believed this would prevent him from having his truck impounded with all his stuff inside. Batman was then arrested and taken to jail. After the shoot, Batman showed me a comic book he'd created called *Stupidman;* it is filled with images of Batman kicking Superman's ass.

While capturing the Imposters in situ out on the Boulevard working for their tips had its merits, the real breadth of certain of these people's devotion and/or delusion became acute when I got into the places they lived, whether it was how the folks acted at home, how their places smelled, or the fact that they were essentially homeless.

That was the case with Jack Sparrow when I photographed him. He was homeless at the time. When he could afford it, he would shack up with some other Imposters in a nearby hotel. The great outdoors may have been a preferable sleeping arrangement compared to how some of Jack Sparrow's peers lived. Freddy Krueger's pad was by far the dirtiest one I had visited, with an unbelievable accumulation of cat hair, and pubic hair! And speaking of cat hair, Captain America was sharing a floor with six cats in an apartment in a rough area of South Central Los Angeles. Marilyn Monroe rented a room by the week right off the Boulevard. It was dirty and depressing, and so small that I had to stand in the hallway to shoot.

Not all the homes of the Imposters were like this though. Some of them were downright normal. Robin had recently moved into a studio apartment in a nice complex and planned on sharing it with his new wife and baby. Gandalf drove from his home in Arizona and would stay with his son in the foothills.

Some domiciles fit the characters to a tee. It was easy to imagine that these Imposters never left character, like Superman and his Superman museum. Elvis lived by himself across the street from the Los Angeles Airport. When I arrived, it was getting dark and beginning to rain. The front door was open and an Elvis song blared from his living room as jets were taking off across the street. His bedroom decor was all white, including a nice hand-held phone and a vanity desk. There was a wet bar in the living room. Zorro's place was a groovy bachelor pad in the plush West Hollywood area. It just seemed right to shoot him on his zebra-stripe couch in front of the wall adorned with his paintings. The paintings, the couch, everything in his apartment was groovy and fly.

During my time observing the Imposters, I did put together a costume. I dressed as Sylvester the Cat with the hope of making some cash, but I realized how difficult it was. First, you need to find a character that isn't taken and is popular with the kids in order to make money. Second, it gets really hot underneath those costumes. Also, waving at people all day on the crowded Boulevard got old real fast. Plus there wasn't a lot of dignity wearing a Halloween costume in Hollywood over the summertime.

But I felt a strong camaraderie with many of the characters and I made some good friends.

Of course, I didn't make any money.

SHAWNA KENNEY: THE WRITER'S WORDS

For nearly ten years I lived two blocks north of Hollywood Boulevard and ten blocks away from the famous Mann's Chinese Theater. On walks around the neighborhood I'd notice 70s-era Elvis taking a smoke-break curbside, Gandalf from the movie version of *Lord of the Rings* sipping iced lattes, or Bugs Bunny boarding an MTA bus with his giant head wedged beneath one sweaty, furry armpit. A friend told me that a Marilyn Monroe lived in her apartment building and often asked her over to play Jenga. I learned that all of the icon impersonators worked for tips, posing with tourists for photos, but were independent contractors—not hired by the local shops. I became obsessed with these people, and pitched the story idea to several magazines (some of them more than once), only to meet with rejection.

Time moved on. Superman cheered for us as we marched in protest against the war in Iraq. A realistic-looking Rambo appeared suddenly down the street in front of the Ripley's Believe It or Not Museum. At one point, there were two Spidermen and two different actors portraying Wonder Woman on the block. New characters came onto the scene as others drifted away, but people continued to pay for a photo-op with the alternative versions of their favorite characters, and I continued to be fascinated by the Imposters and the tourists cozying up to them.

Eventually, I got a call from my longtime editor Roger Gastman at *Swindle*. He'd met a photographer who'd been shooting the Imposters in costume in their own homes. "So I finally get to do the story?" I asked. He consented. In photographer Jim Knoblauch I found a kindred soul—someone already documenting the characters in costume, yet in their own environments—fantasy and reality captured in a visual duel. Throughout the interviewing process, friends humored my obsession as I complained of incessant calls from Jimi Hendrix or excused myself from lunch, ringing cell phone in hand, yelling, "Sorry—it's Spongebob! He doesn't have an answering machine and I've gotta take this!" I received tons of emails announcing the arrests of Elmo and Chewbacca. Jim sent me priceless notes, giving me background on my subjects before I spoke with them: "Loves Mariah Carey" or "slightly paranoid" or "Lives with Cat in the Hat." Some of them graciously allowed me into their homes. Some of them had a hard time breaking character. Some of them had their phones disconnected before I could contact them. But like the dorky fan photos I keep behind plastic in my albums, all of them stay with me.

Considering that the local bus tours mainly show former homes of long-deceased screen legends, the Hollywood sign is not lit up at night like it looks in movies and Disneyland is expensive, it's bargain entertainment, really. Millions trekking from far ends of the earth to Los Angeles every year head straight to the heart of Hollywood with vain hopes for a close-encounter of the celebrity kind. And despite the mid-90s billion-dollar facelift, many are still shocked by Tinseltown's lackluster facade. But have no fear—

entrepreneurial souls live here! Thanks to the Imposters, kids and grandmas still go home with one-of-a-kind portraits of themselves with their favorite superhero or movie character. Never mind that some call these street performers panhandlers, or that local businesses have described them as a "nuisance." The Imposters are ambassadors of sorts. After all, you won't catch real celebrities hanging out on Hollywood Boulevard.

It is said that imitation is the sincerest form of flattery. Consider the exuberance and abandon with which most Americans celebrate Halloween—an annual chance to pay homage, move anonymously behind make-up and masks, or escape completely into the image of another. The impetus for the Imposters featured here is a universal one. Many of them are aspiring actors just using this as a day gig. And who can blame them? There's no boss to answer to or set schedule to keep. Everyone who comes to Hollywood feels like they could really be somebody. In the meantime, it might just pay better to be somebody else.

Is the very existence of the Imposters evidence of market-branding's powerful nature? Or is working-class society so desperate to brush with celebrity that mugging with imitations is an acceptable second-best? Whether art or aberration, I look at the whole experience this way: I got to know my neighbors a bit better. The magazine article was published. And now the article has evolved into a book, meaning the Imposters are reaching audiences far beyond the Boulevard. It may seem a sappy Hollywood ending. But hey, as the anthem goes, "That's entertainment!"

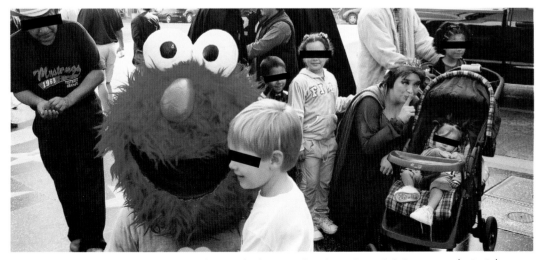 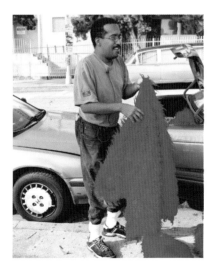

Imposter Don Carol Harper, enjoying a day as Elmo. He also has a regular stint as Spongebob Squarepants (pp84-85).

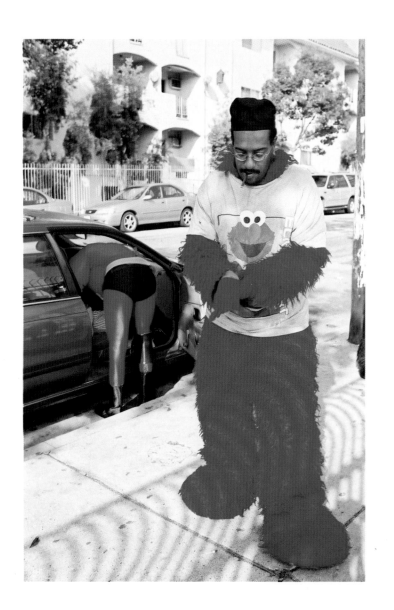

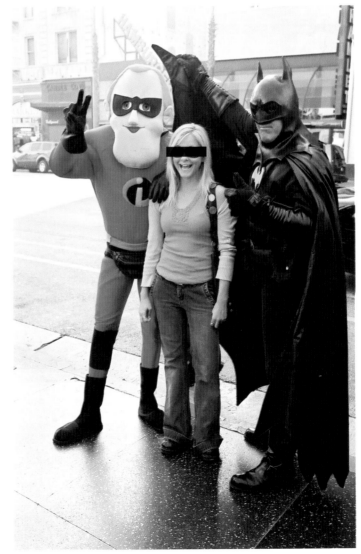

SUPERMAN by Christopher Lloyd Dennis

« *I collect Superman but I also collect Playboys.* »

Last job: Shark fisherman.

Costume: Custom-made tights; the belt is an actual prop from *Superman 3*.

Number of times Chris's girlfriend Bonnie saw Superman movie before meeting him: 44.

Where he and his girlfriend met for the first time: Re-release of *Somewhere In Time*, starring Christopher Reeve and Jane Seymour.

Location of their first date: Metropolis, Illinois, at a "Superman Celebration."

Hardest-earned tip: $30 for lifting a 300-pound woman at the request of her husband.

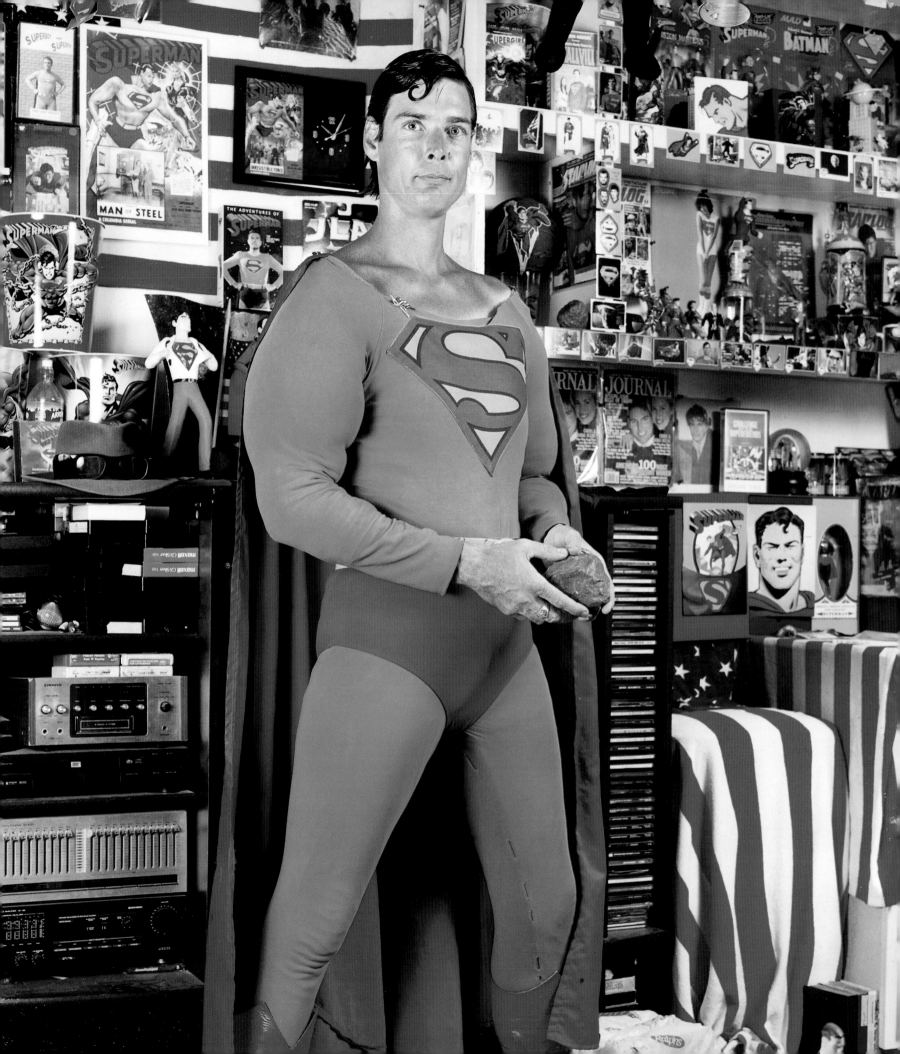

SUPERGIRL by Joelle Arqueros

« *If I go to Vegas and lose all my money, I go to the car, put on my costume, and BAM!, make more!* »

Education: Hollywood High; BFA, Tisch School of the Arts at NYU.

Last job: Aerobics instructor.

Other Job: Running her own theater company.

Costume: A little girl's Halloween costume, plastic shorts, and boots from a stripper store.

Who suggested she become Supergirl: Superman Christopher Dennis.

Best part of job: How happy it makes little girls.

Worst part of job: Wives who get mad at their husbands for taking her picture.

Superhero earnings: At least $100 for 4 hrs a day whenever I feel like it.

Biggest fan: *Days of Our Lives* star Nick Reed.

Funniest experience on the Boulevard: This Italian construction worker said, "I'd take that Supergirl on my dinna' platta' any day of the week."

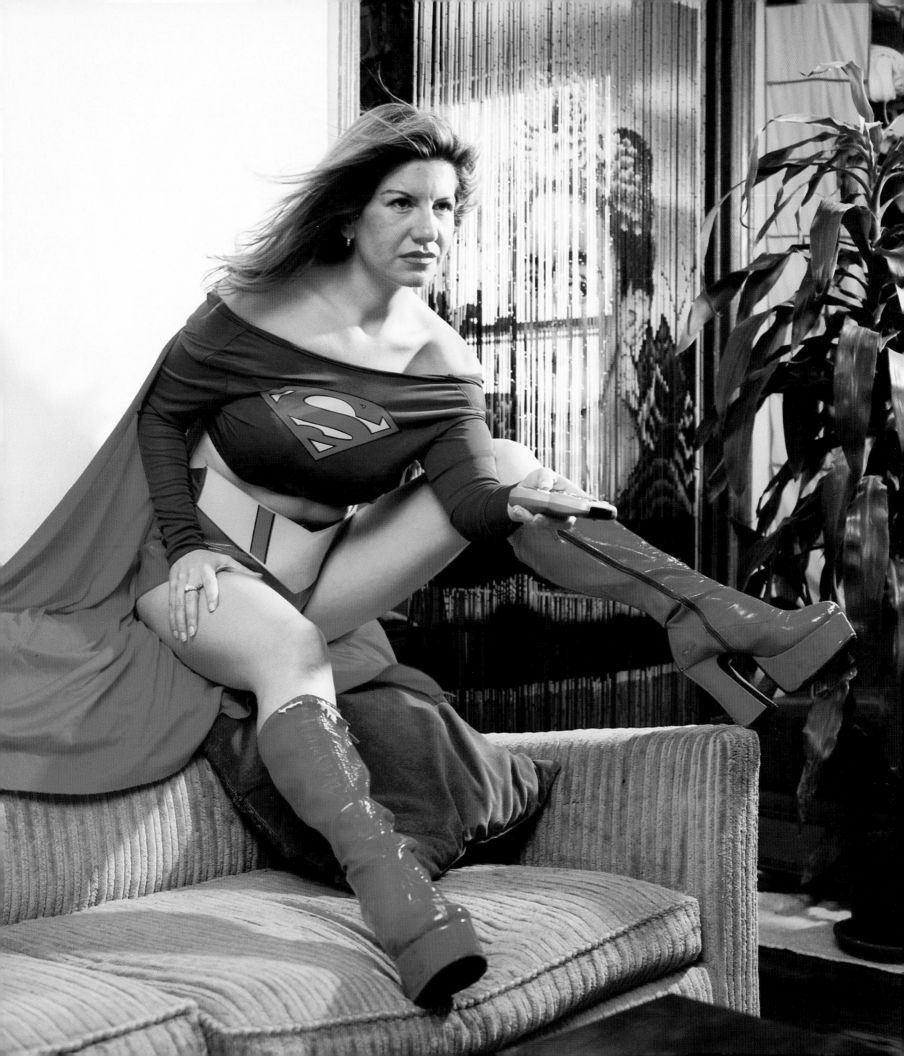

WONDER WOMAN by Dana

Jim's Blurb:

Wonder Woman's apartment looked and smelled like my grandmother's house: shag carpet, lots of antique furniture and nothing seemed to be out-of-place. Wonder Woman's new pair of panty hose seemed to really work with her outfit and she was a natural in front of the camera.

She was pissed that I had to come back over for a re-shoot and I only got to shoot half-a-roll of film. Before each shot she yelled at me about taking too long. But she was back to her pleasant self afterwards.

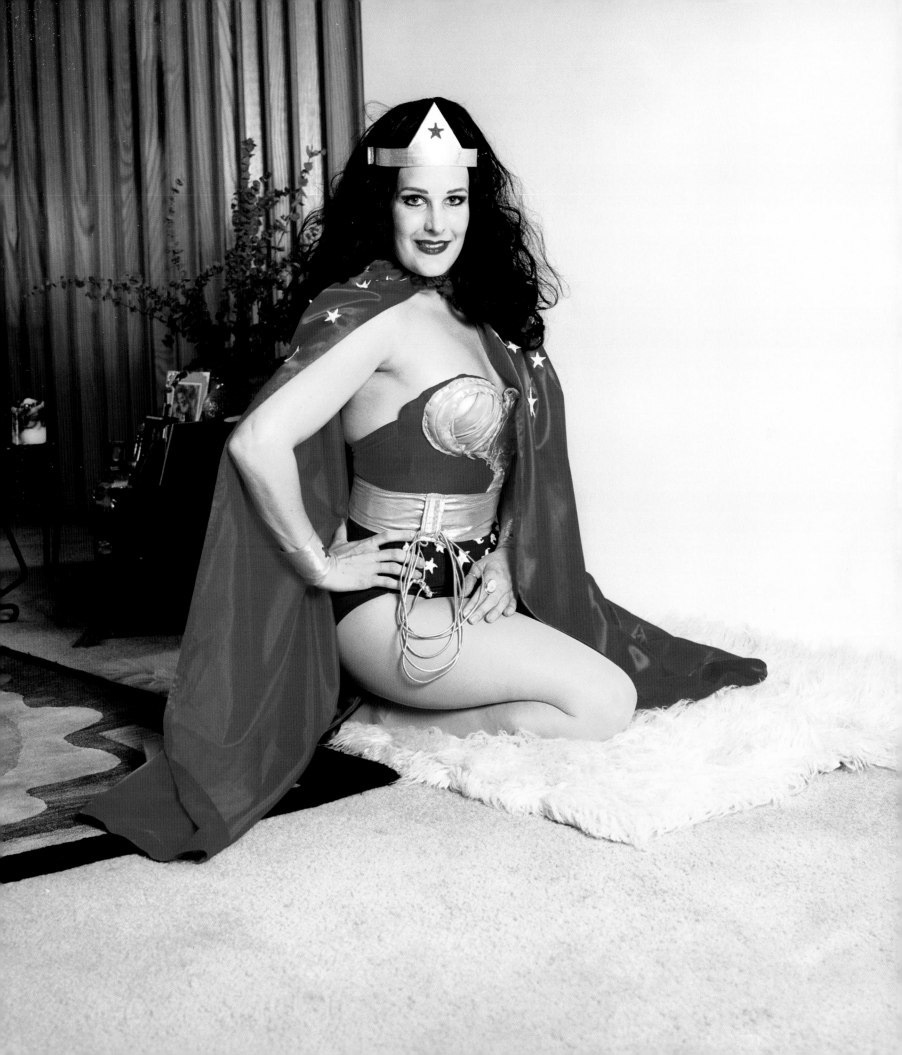

WOLVERINE by Esteban Marinos

« *When I was a kid I used to howl like a coyote.* »

Age: 32.

Hometown: Riverside, CA.

Other Jobs: Firefighter; service technician for a plumbing company.

Costume: One of my costumes was made from my old motorcycle outfit, but now I don't fit that one because I got too large. Now I have a couple spandex. I get leather paint and draw the designs. I stick with leather even though it's hot, it's more comfortable and with spandex it feels like I'm wearing underwear out there. I look more like the cartoon character when I'm wearing the spandex, but I prefer the Levi's and tank top and leather jacket. My chops are natural. To make my hair stick out it's hairspray, blowdryer, and a fine-tooth pick. I've got three sets of blades that I have tattooed on my hands, like the ones Wolverine has sewn in, and it looks like they're coming out of my hands.

Why an Imposter?: I do this for fun and family but I go to comic conventions every year because I look just like the character. I look like him every day. I never knew the Wolverine character would capture my mind. When I saw the movie I flared my hair out like him and thought, "That's pretty cool." Then I shaved one time and four months later this kid said I looked like Wolverine. Riverside has a Castle Park for Halloween; they hired me off the bat because I looked like him, so I was standing out there with my blade, next to Freddie Kreuger.

Best part of the job: The expressions from the parents or kids when they go, "Oh my god, this guy looks like him."

Worst part of the job: People laughing at me in regular life thinking I look like him, but not knowing I am him, that I impersonate him on the side. No one knows unless I walk with a shirt that says "Property of Marvel" on it, or a shirt with me on the back. No one knows. If I'm not wearing my blades, they have no idea what I do.

Secret weapon: My blades inside my jacket, and having a short temper.

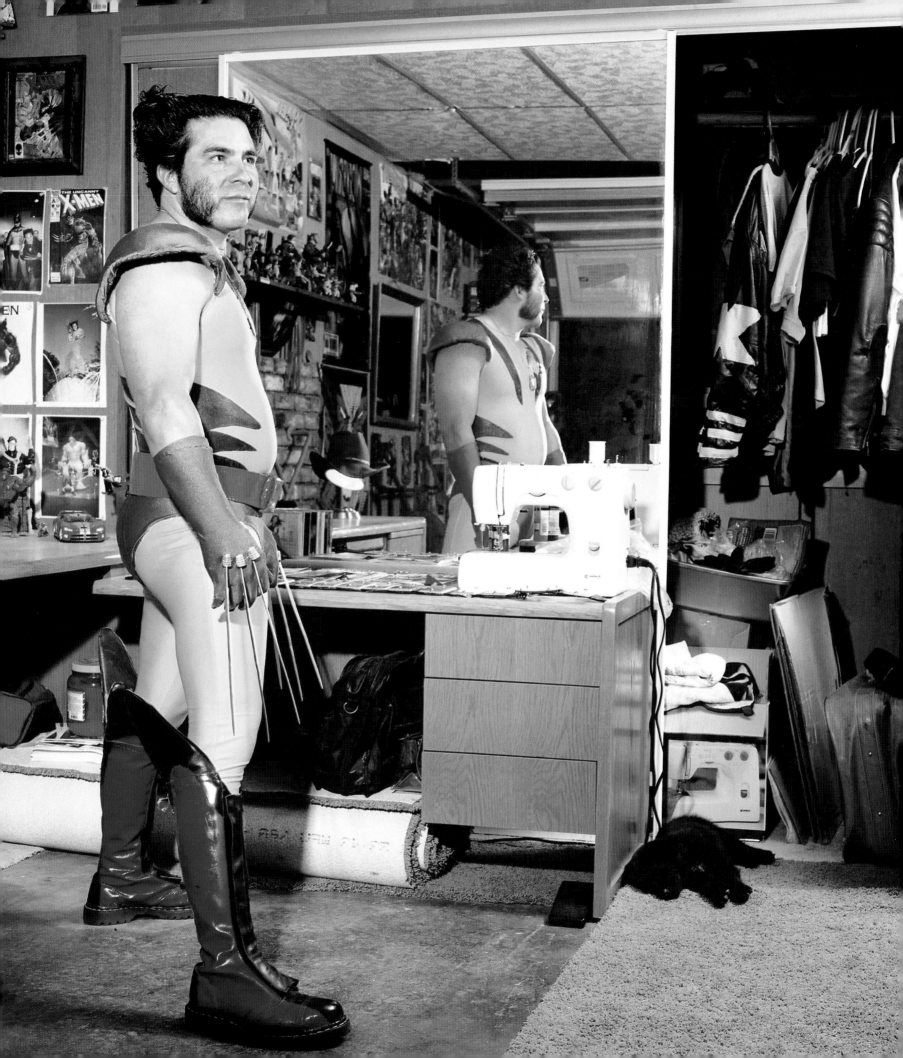

BATMAN by Max Allen

« *I've had 4 or 5 fights. Sometimes guys get drunk and want the reputation of beating up Batman. But I'm a martial artist.* »

Hometown: Austin, Texas.

Other job: George Clooney movie stand-in.

Hobbies: Working out, screenwriting, and playing videogames.

Costume: The cape is 7 1/2 pounds of leather and satin.

Career mentor: Superman.

Marital status: Wife was first Catwoman on Boulevard.

Criminals stopped while in costume: 2 purse-snatchers, 1 shoplifter, and 1 assailant.

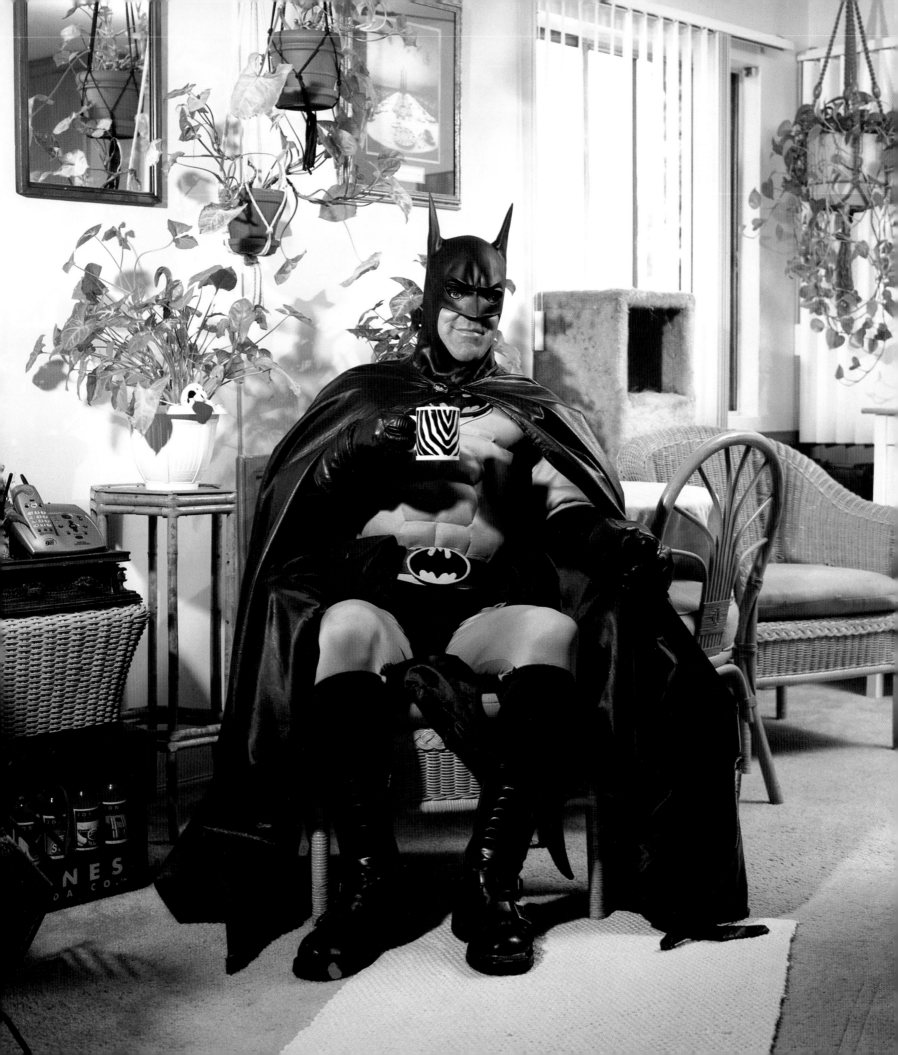

CATWOMAN by Dana Kelly

« Catwoman is an excellent thief and she is totally hot! »

Last jobs: I worked in a gift shop on Hollywood Boulevard called "Hollywood Souvenirs" for 4 years. I was also the manager of a theme park called "Haunted House Attractions."

Other job: Nursing school.

Best experience on the Boulevard: Being on the Jimmy Kimmel Show in the "Superhero Olympics."

Worst experience on the Boulevard: Getting slapped on the butt. But I then kicked the guy in the shins.

Other impersonations: The Bride of Frankenstein.

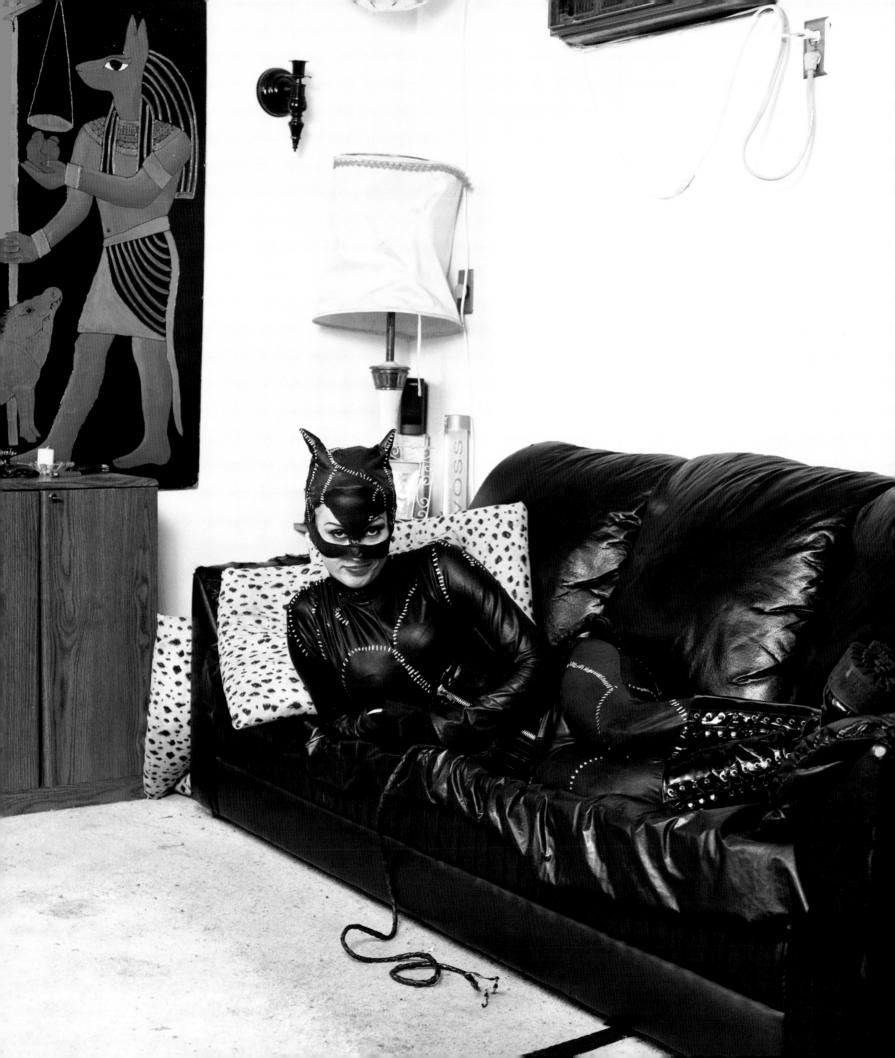

ROBIN by Harry Kallet

« I take my extra clothes to work with me in a fanny pack, because I don't like taking the bus in costume, and if we put our regular clothes down, homeless people steal them. »

Age: 39.

Last job: Professional cliff-diver in Waimea, Hawaii.

Costume: The boots are women's size 15 and cost $60.

Why an Imposter?: I hurt my back cliff-diving, moved to cheap apartment in LA, needed just enough money to pay rent... worked as Frankenstein's Monster at the Wax Museum for awhile but the 45-lb costume was too heavy and hurt my back.

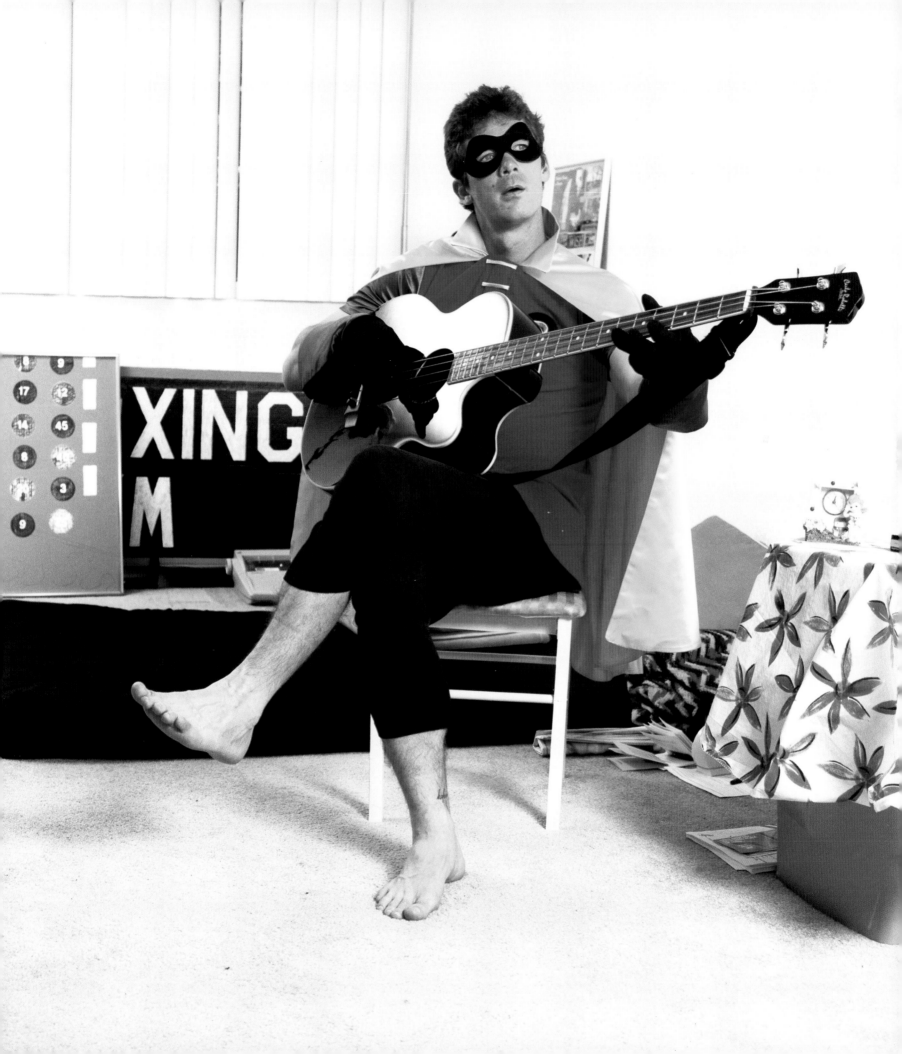

CAPTAIN AMERICA by Toney Tomey

Jim's Blurb:

Captain America's shoot took place during the middle of the night in February. The apartment was in a very bad area in South Central Los Angeles and belonged to one of his friends. The Captain was sleeping on the floor with six cats.

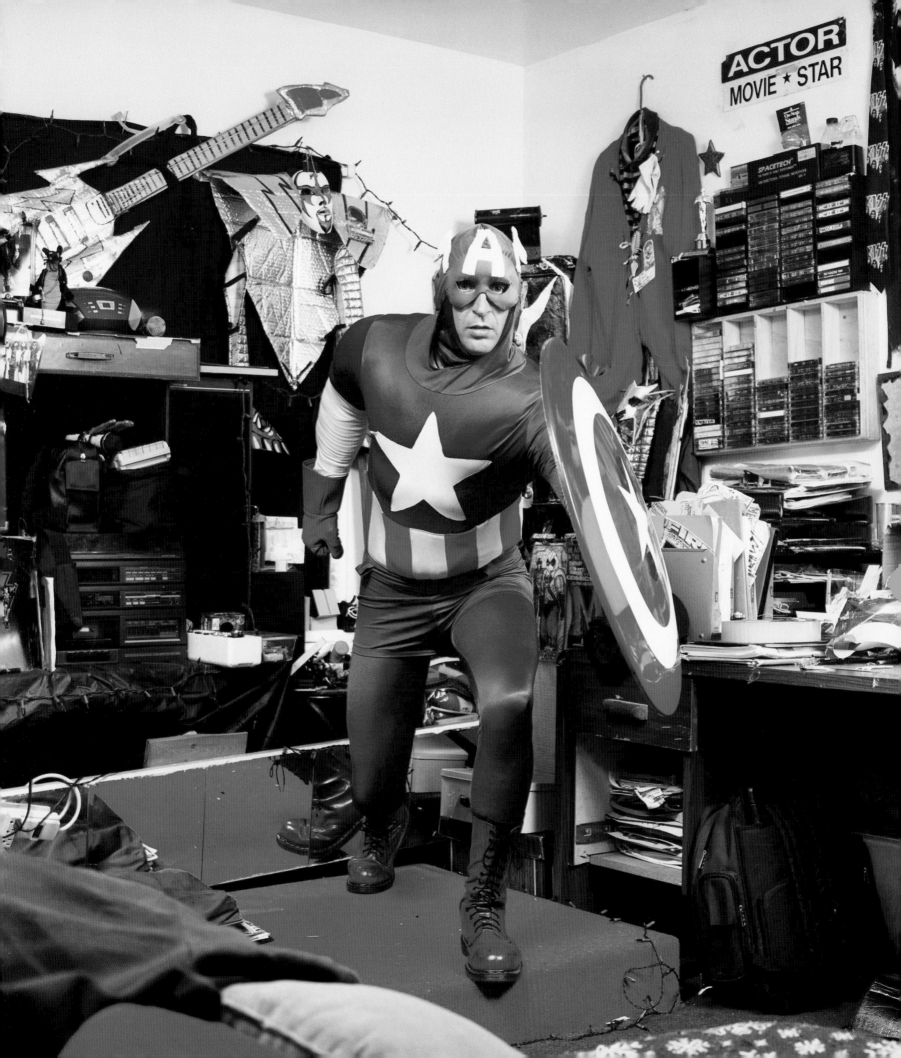

SPIDERMAN by "Nick"

« My ass gets grabbed about a half-dozen times a year. »

Other jobs: I do birthday parties for kids in a few different costumes. One bizarre job was when I was paid by a woman to impersonate her brother in front of her boyfriend for over two years.

Best part of the job: Can't get fired.

Worst part of the job: The heat and being on your feet all day.

Secret weapons: I can always strike a pose and shoot a web.

Other perks of being an Imposter: I recently went to New York City and made a lot of money in Times Square.

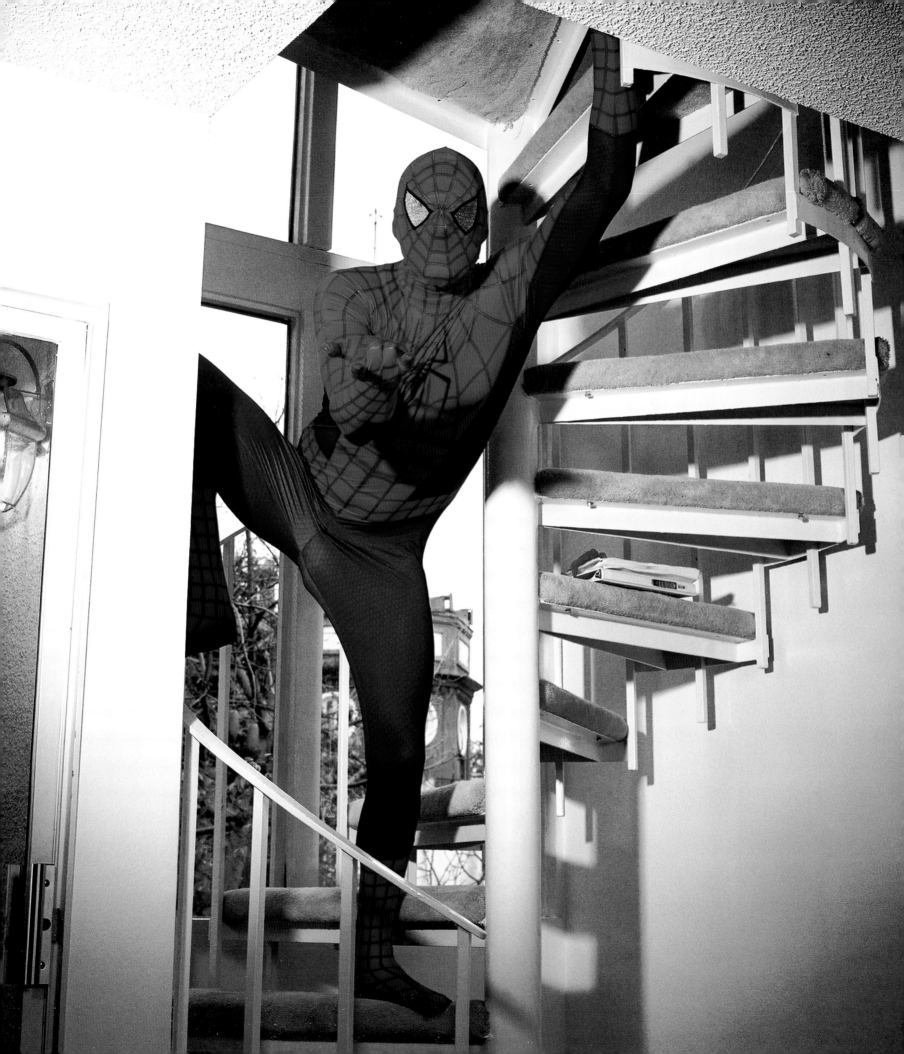

THE INCREDIBLE HULK by "Who-dat"

Jim's Blurb:

The Incredible Hulk was living in a nice low-income apartment building in the foothills of Hollywood. He was splitting his time working on the Boulevard as Hulk and working at a video store waving at cars in his Hulk outfit. Hulk is also an actor and has appeared on Jimmy Kimmel, in character.

He was stressed-out, having just lost his cell phone. He only had a mattress and a Hulk glass in his studio.

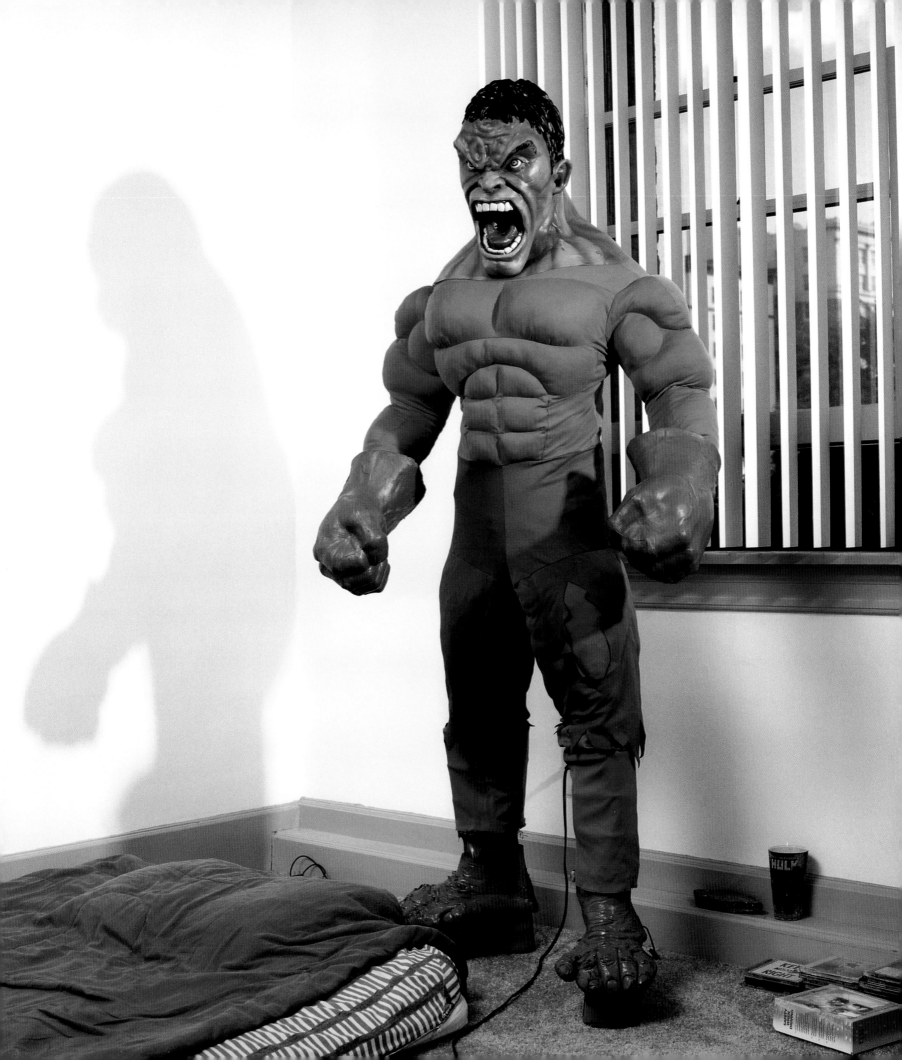

FREDDY KREUGER by Gerard Christian Zacher

« I treat it as an art. I go the extra mile. »

Age: 37.

Hometown: Chicago, Illinois.

Last jobs: Worked for a spa resort and as an attraction assistant at Disneyland.

Other jobs: I also do a cheaper version of Brahm Stoker's Dracula, Beetlejuice, Peter Pan, and the Grinch.

Costume: A sweater, pair of pants and the hat; a custom-made claw; special effects make-up that takes as much as two hours for me to apply.

Why an Imposter?: I do this for the art of it, for my own experimentation and to practice special effects make-up.

Best part of the job: Entertaining people and having fun with the public.

Worst part of the job: Being affiliated with people who do this for their own reasons, as a quick way to make a buck. That's not my purpose. Sure, when they tip it helps, but that's the least of my reasons for it. My reputation gets linked to them and I don't like that.

Best day on the Boulevard: My make-up got the attention of the cast and crew of the *Friday the 13th* movies—they had a celebration in our area—and I made some acquaintances, like the original Jason.

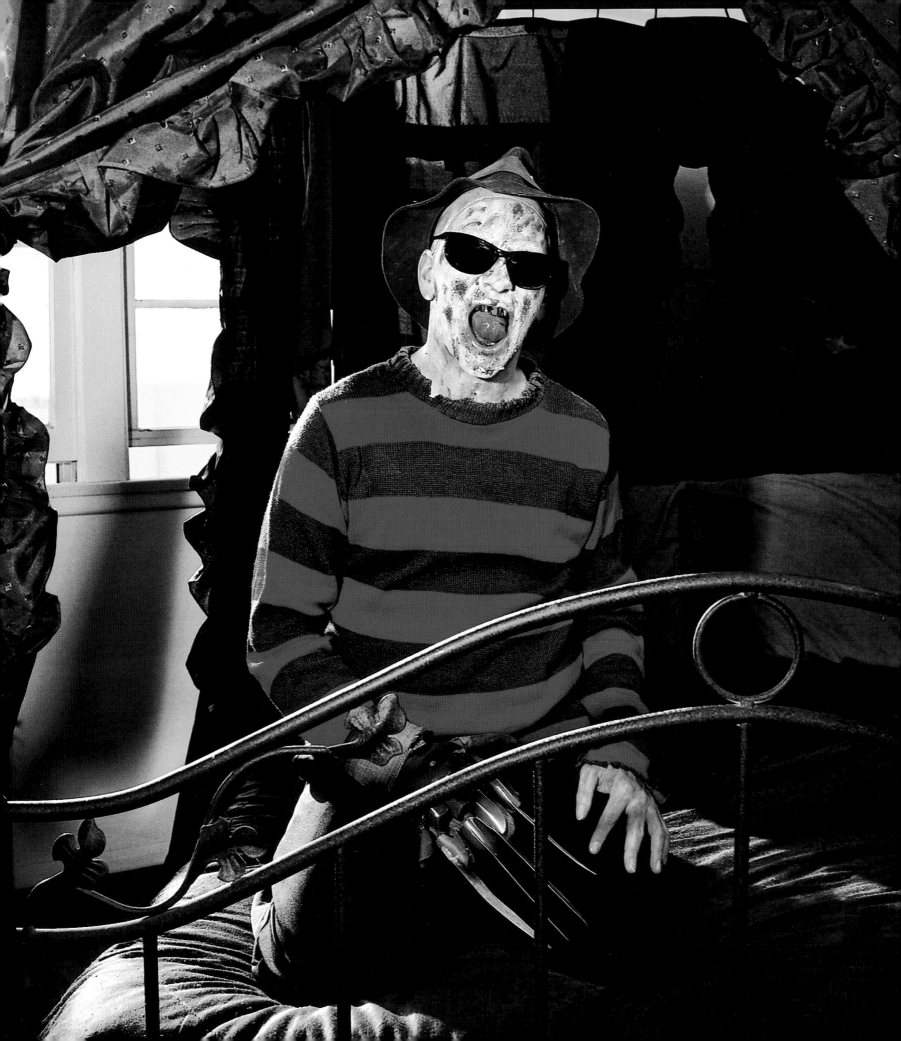

MICHAEL MYERS by Art A. Gomez

Jim's Blurb:

Michael lived in a studio apartment with his mother in a Latino area of downtown Los Angeles. His cousin came over and I took head shots of him since he was a magician and needed promo shots. After the shoot, we all ate pizza and Michael Meyers told me that his mother was really proud of him. Before I left, he gave me one of his Michael Meyers dolls as a gift.

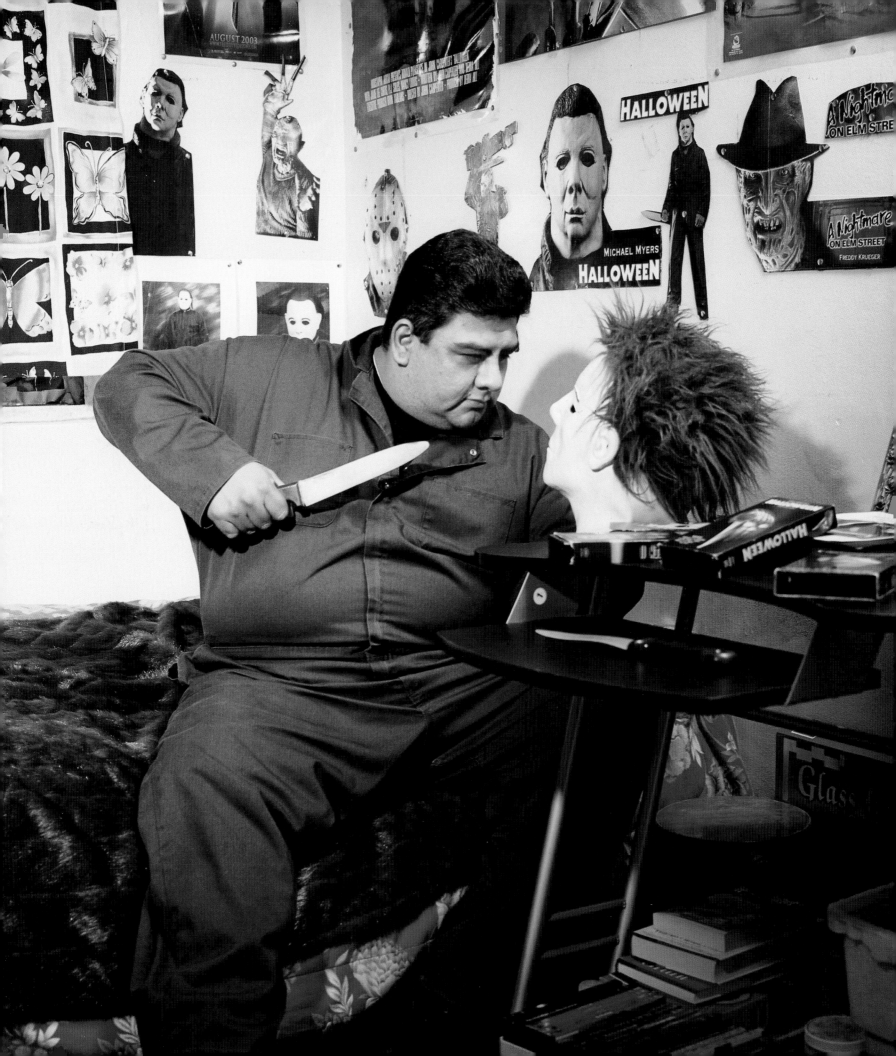

CHEWBACCA by Uchenda

Jim's Blurb:
Chewbacca had a studio in Hollywood that was so packed with stuff that we had to shoot outside at the back of his building. He seemed to be somewhat of a loner. He also held a job as a bouncer in a nearby bar. His future plans included shooting porno films with a friend.

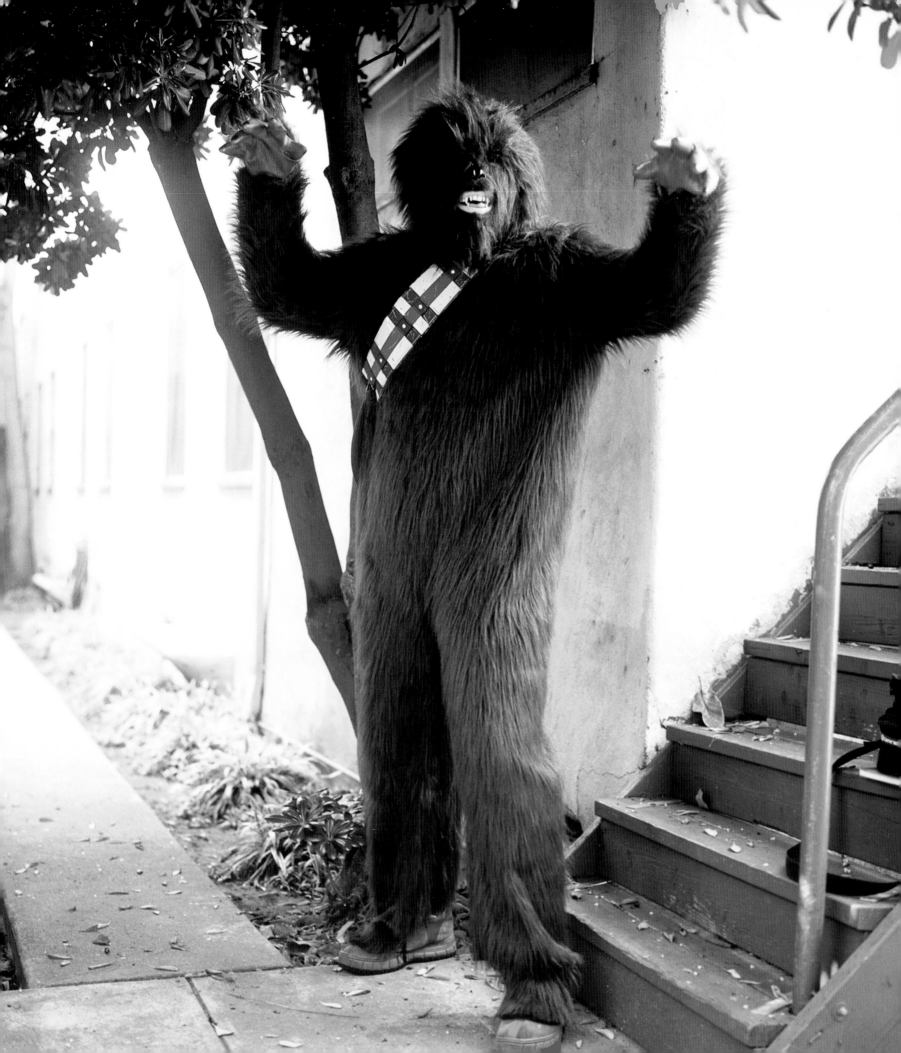

YODA by Don Carl Harper

Jim's Blurb:

I was really interested to see Yoda's apartment. He is an articulate and well-organized fellow that knows that there is something else to life besides working the Boulevard. While I'm walking-up to his house, I heard harp music playing and a beautiful woman—his wife—opened the door. She told me that Donnie would be out soon.

When he came out he asked me what Yoda's crib would really be like in 2006. After a rather lengthy phone conversation with his mother in Chicago, we tried to reenact what Yoda would do after a long day out on the Boulevard.

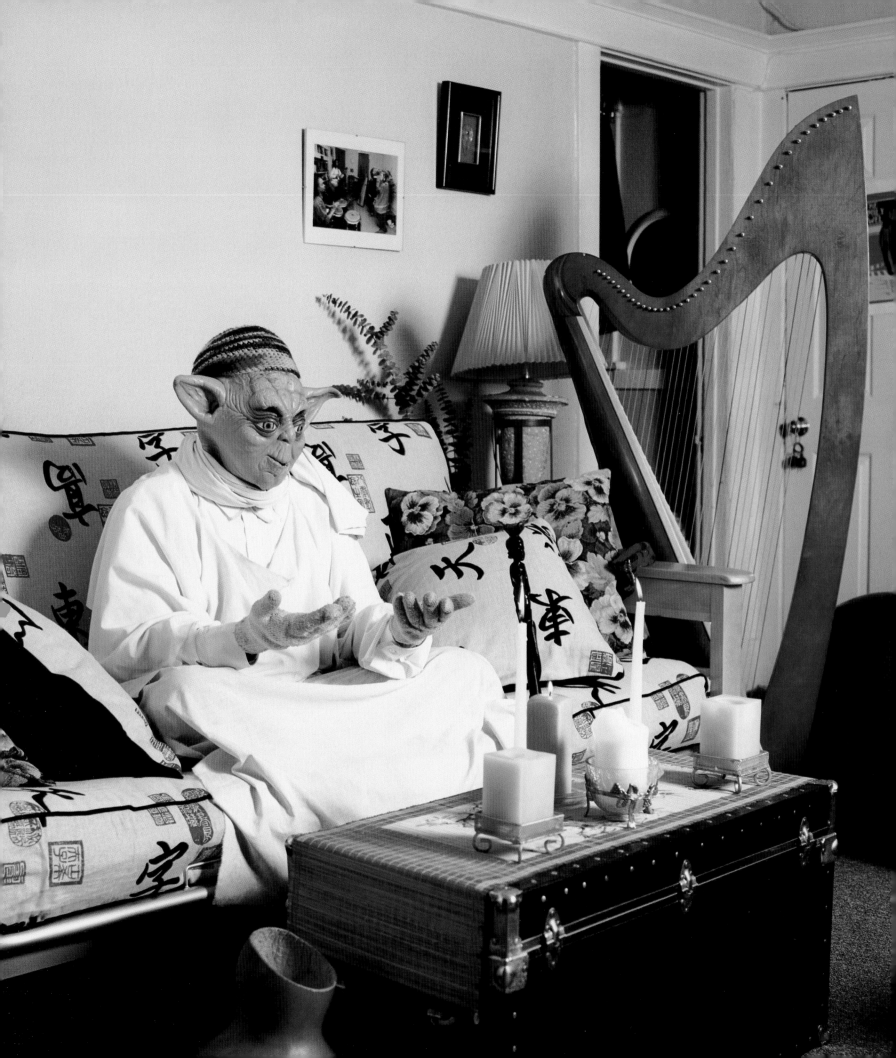

STORMTROOPER by Jay Netka

« People want to see how punch-proof the armor is. I've had to return some punches. I use to be a bouncer in a nightclub, so I know how to handle myself. »

Height: 6'6".

Last job: Civil engineering.

Last acting job: An extra in *The Italian Job*.

Costume: From a movie-prop shop; custom adjustment of battery-powered fan inside of the helmet.

Other experience: Posing as a Stormtrooper at Seattle Star Wars Society convention.

Peer Praise: Biggest money-maker on the Boulevard.

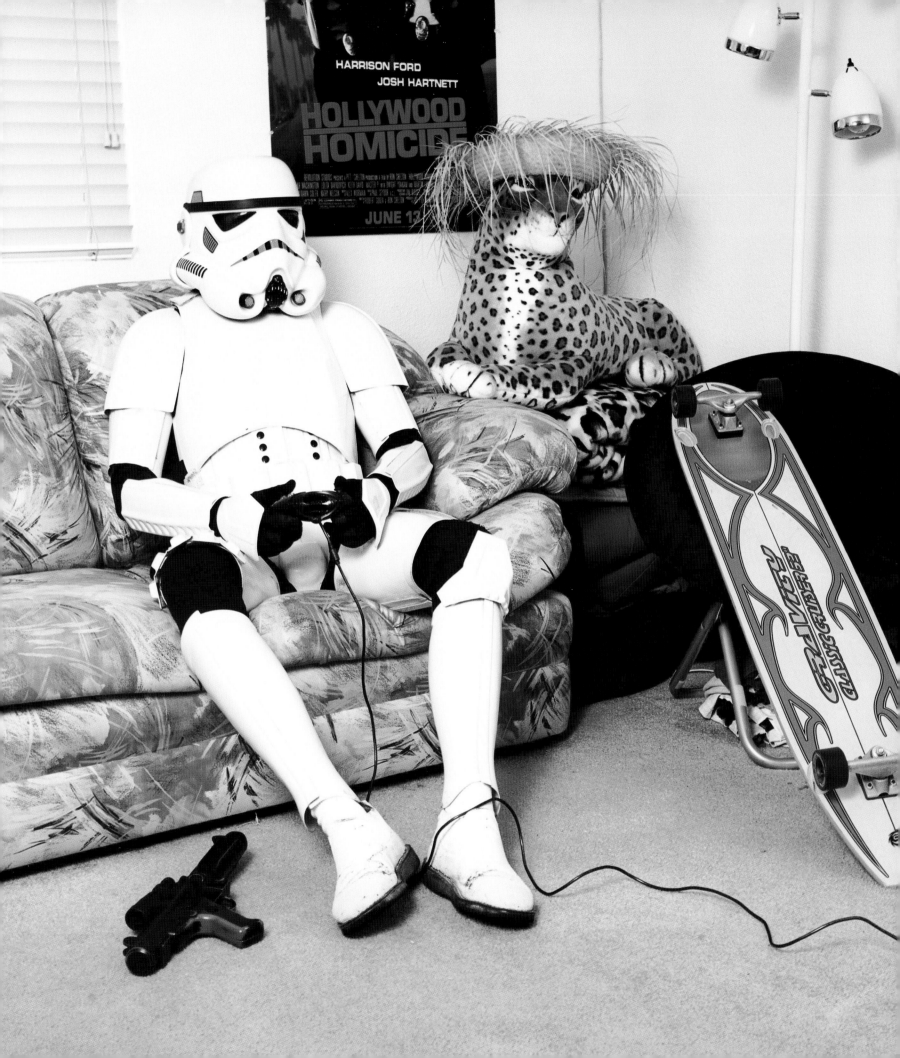

JACK SPARROW by Michael A. Luce

« My priorities are to first make rent at my motel, then get a date to the movies. »

Costume: My belt is the bed sheet from the motel where I live.

Best part of the job: I get lots of dates while being Jack Sparrow. I've been kissed on the lips lots of times, and some have gone 100%.

Secret weapon: I have a southern upbringing so my personality is pleasant and it gives me skills to perform socially. I was also a comedian when I was younger.

Most interesting experience: I had two different dates at the same time during a movie. I met both girls on the Boulevard as Jack Sparrow and was fooling around with both of them in the back of the theater.

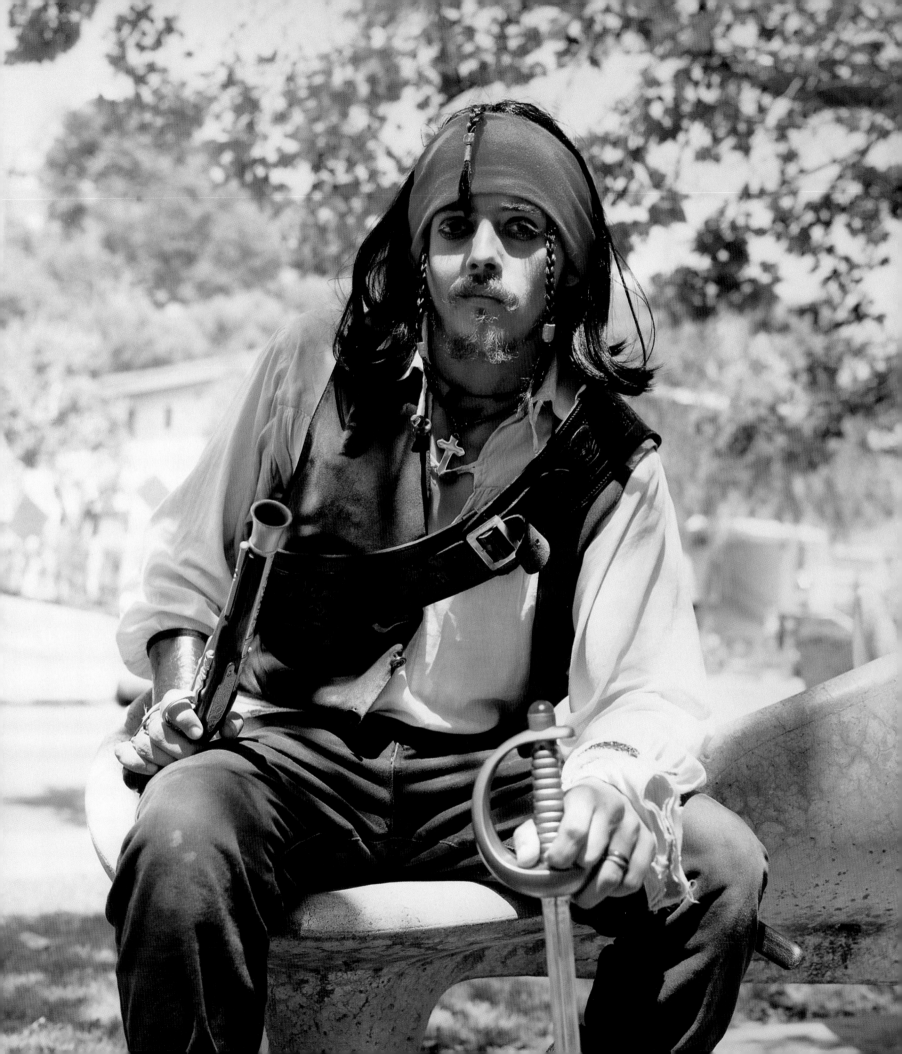

LEGOLAS by Jordan Wood

« *When your mind is becoming the character you are portraying, that's a major problem.* »

Last job: Sold credit card machines.

Other experience: I have a black belt in Judo and I am trying out for the 2008 Olympics with the British Archery Team. I am also a trained actor.

Best part of the job: Working with children. I know a dozen children who are going to take archery lessons after watching me with a bow-and-arrow.

Worst part of the job: When characters have arguments with each other in front of the children. What would it look like if Legolas and Princess Fiona were having a relationship fight in front of everyone?

Other impersonations: Harry Potter, Frodo, and a ninja.

Relationships with other Imposters: There are times when I have to hold a character against the wall and discuss their behavior at the point of a bow and arrow.

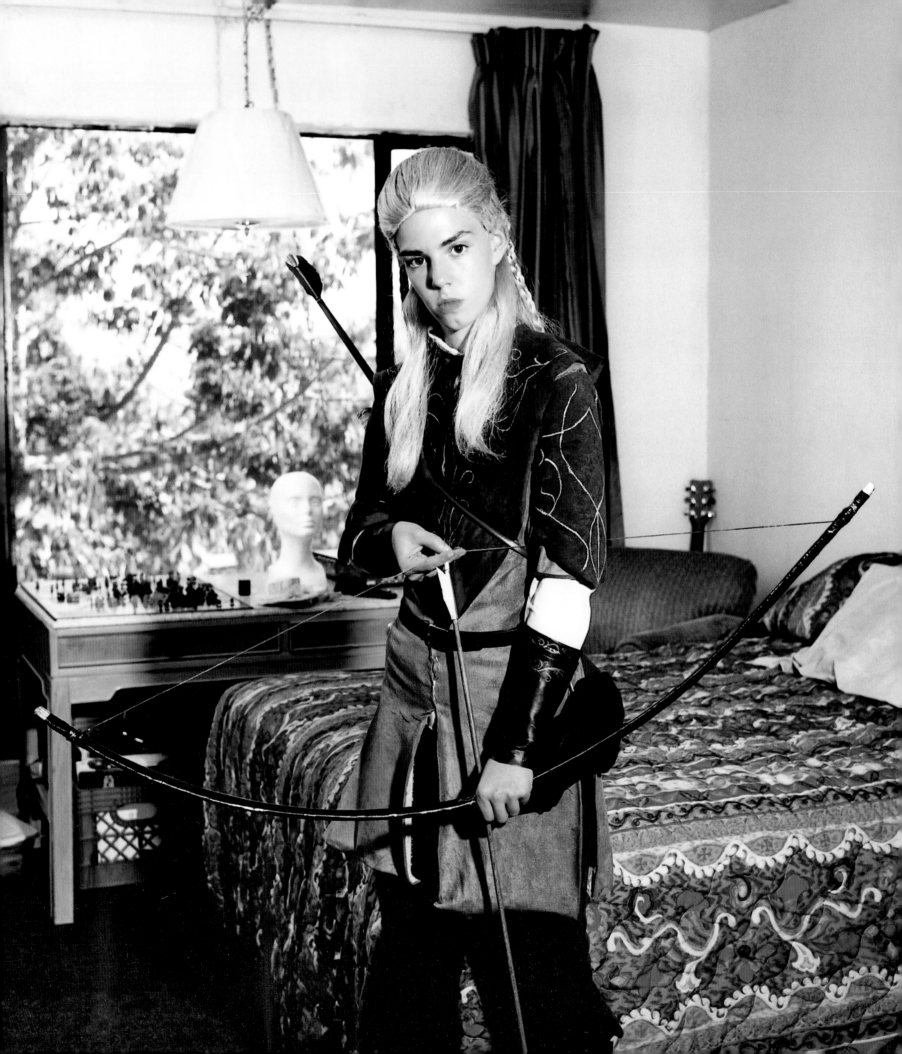

GANDALF by James Richard Patterson, AKA "Red"

« *I portrayed Gandalf the White. The other guy did Gandalf the Grey. To prevent confusion, sometimes I'd double as the wizard Saruman.* »

Age: 64.

Original Hometown: Denver, Colorado.

Present Hometown: Phoenix, AZ.

Costume: I made it all myself. Some of the beard was mine, part was added. The hair was extensions.

Best experience on the Boulevard: Bringing the character to life and doing his schtick.

Worst experience on the Boulevard: When it rained it bummed me out. There were also no amenities out there, like you'd have on a good set.

Reason for quitting: After two years of doing it off and on the character lost its appeal and it was time to move on.

Current job: Running a character representation business and performing as a clown, barker, or "whatever is needed" 2-3 times per week.

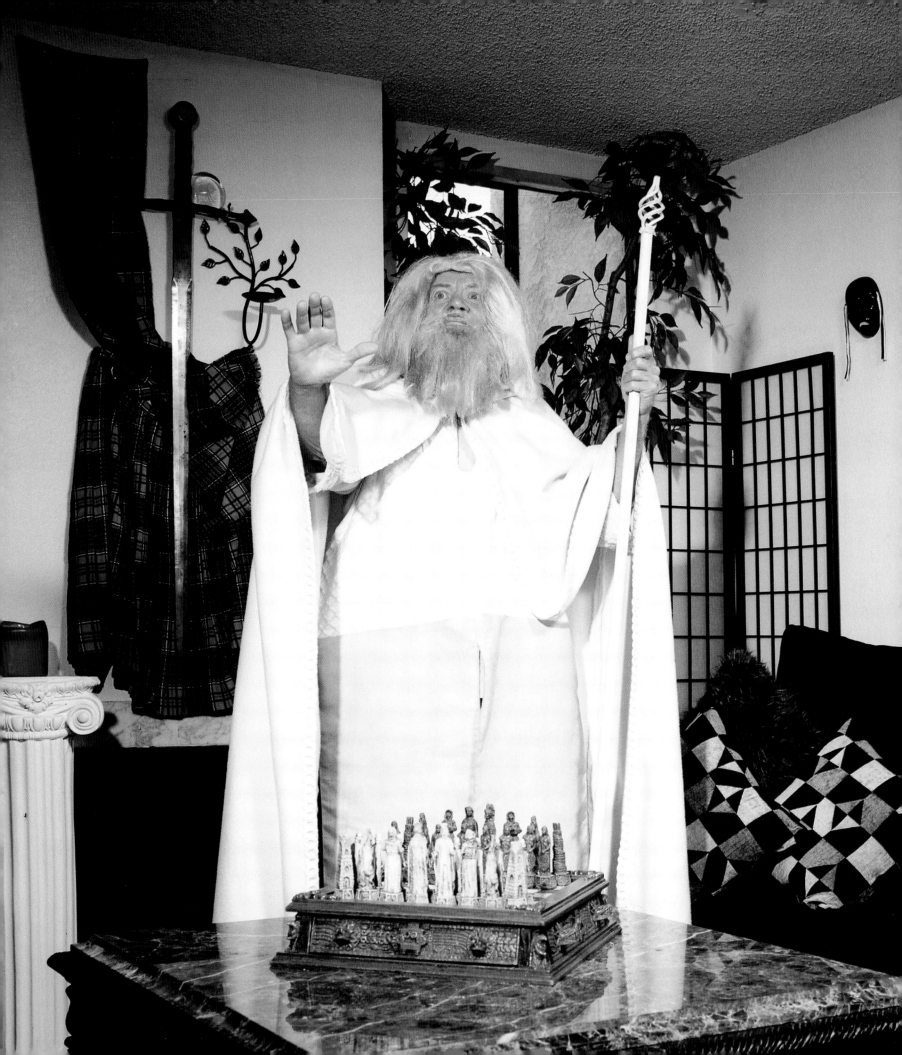

ZORRO by Jason Perez Morciglio

« *This Latin transvestite and this drunk black woman were both showing me their boobs right there in front of everybody. Then the guy stole a remote control car from this gift shack. I walked a bit backwards because I didn't want to be a part of that circus.* »

Age: Artistic age, 25; real age, 33.

Hometowns: San Francisco, Puerto Rico, Argentina.

Last job: Tango instructor.

Costume: The cape and belt are made in Argentina. I bought the boots from a Renaissance Fair website. I have five different masks, but my first was a modified do-rag.

Why an Imposter?: In 1999, I won a costume contest in Argentina dressed as Zorro. Later I lived in San Francisco and visited the Wax Museum while in Hollywood, and Diego (Rambo) was there, and he is Argentine too, and he suggested characters for me. I was almost The Crow. But I've been doing Zorro for five years now.

Best part of the job: Interaction with people, and the tips. I have time to write screenplays and act in movies.

Worst part of the job: The competition. There have been other Zorros, but I challenge them with my sword, then let the people decide, which encourages them to go away. I can't afford for there to be two.

Romance: I meet lots of girls as Zorro. Most of them don't take me seriously, but at that moment, they let go. We hug and kiss, and if it goes a bit beyond that, I cover them with my cape.

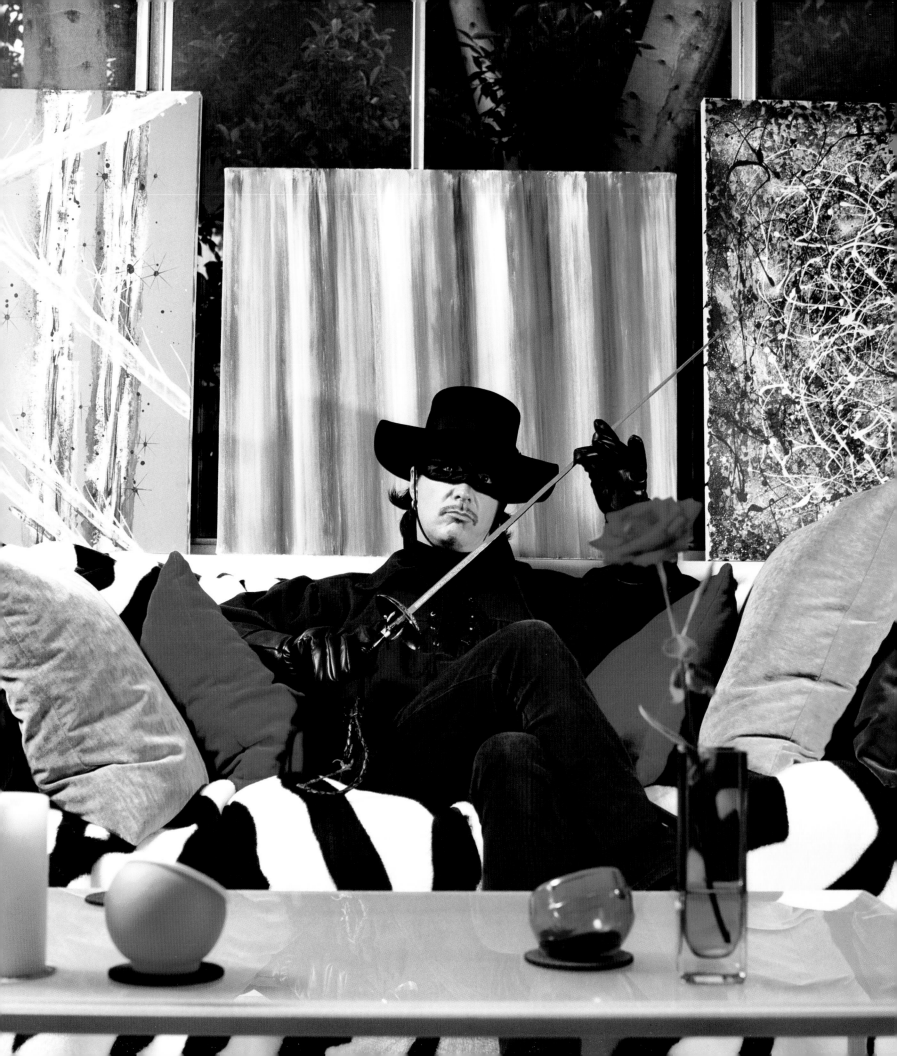

SEXY COP by Kristen Inberg

« *I saw a woman get hit by a bus.* »

Age: 20.

Hometown: Nebraska, but moved to Colorado at age 14.

Education: Graduated from Valley High School, 2003; accepted to Colorado School of Mines to study Chemical Engineering but decided to model instead.

Last jobs: Modeled in Italy, Turkey, LA, and Colorado. Stopped performing as Sexy Cop in November of 2004.

Costume: A button-down shirt dress with a belt around the waist, which leopard-skin handcuffs hang from; knee-high boots with two handguns in the top of each; fence-net thigh highs; a police hat.

Why an Imposter?: Learned about the gig from Spongebob.

Editor's Note: While not a proper Hollywood character, the presence of such an Imposter on the Boulevard speaks to the fantasy aspect of the phenomenon. When the kids scurry off to mug with Elmo, dad rubs up against Sexy Cop.

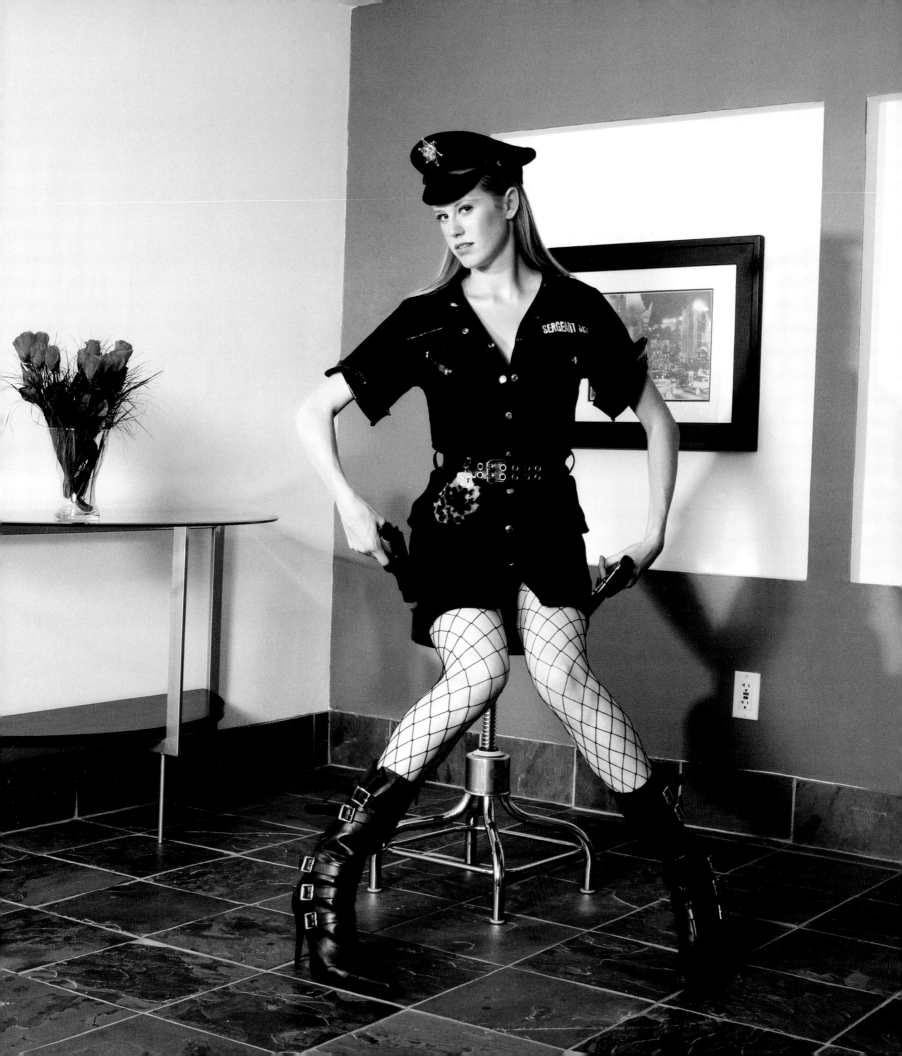

ELVIS by Michael Romeo

« My wife is a supermodel from Spain, so anytime Elvis and a supermodel walk into a room, we attract a lot of attention. »

Age: 32.

Hometown: Westchester, CA.

Last job: Boat detailer.

Costume: A seamstress makes everything for me custom-made. All of my outfits are Vegas-era, like the white and gold karate jumpsuit. The sideburns and hair are all natural, baby.

Best part of the job: Helping people smile on the inside and outside. While they're talking to me they forget about their troubles—being able to do that everyday is a joy. Putting that suit on is making a lot of people happy.

Worst part of the job: The sun. I get a suntan and get a big "V" on my chest from the suit, and tan-hands with finger rings around them. Also the tight suit keeps getting tighter and tighter every year, where you don't want it to be tight.

Secret weapon: My personality.

Acting credits: *The Girl Next Door*, *Kiss Kiss Bang Bang*, and TV show *Las Vegas*.

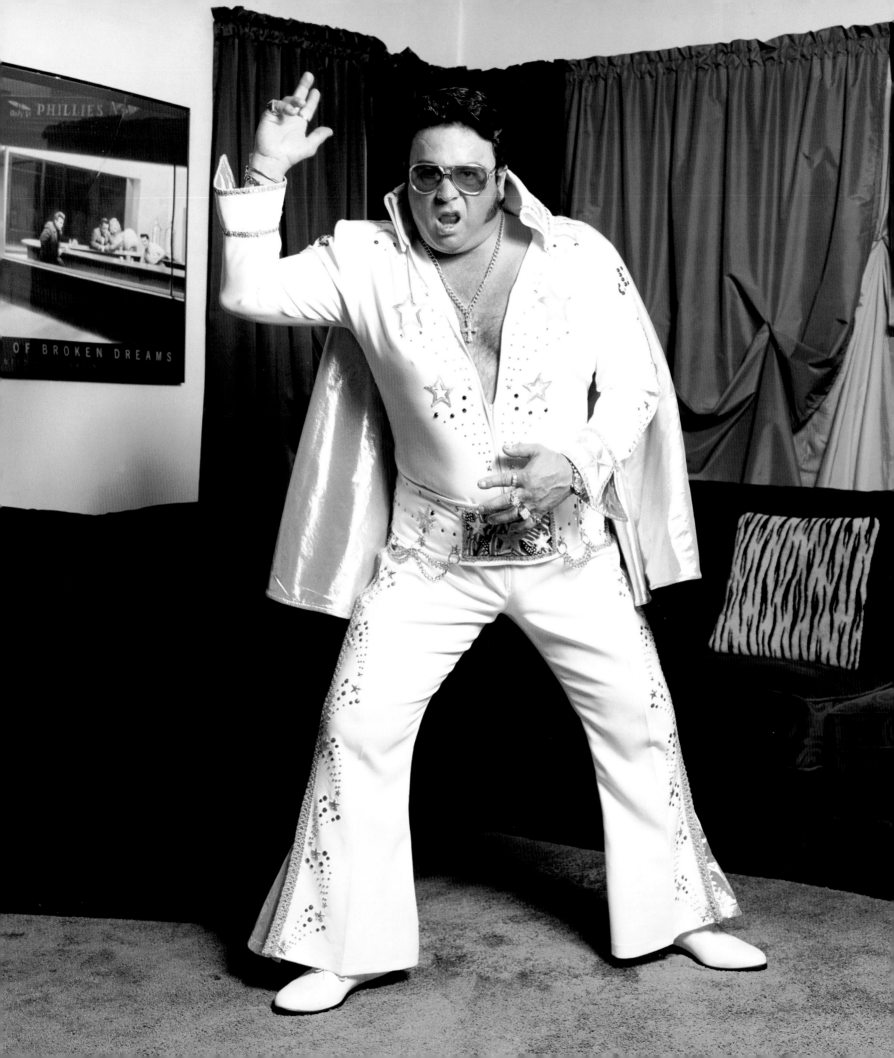

AUSTIN POWERS by "Scott"

Jim's Blurb:

Austin was living by himself and seeing his girlfriend in San Diego most weekends. His studio was neat and tidy with lots of sunlight. While studying to become a nurse, he was going to the Boulevard with his friend Zorro to make quick cash. At the end of the photo shoot, he thought it would be cool to jump into the hammock for a shot.

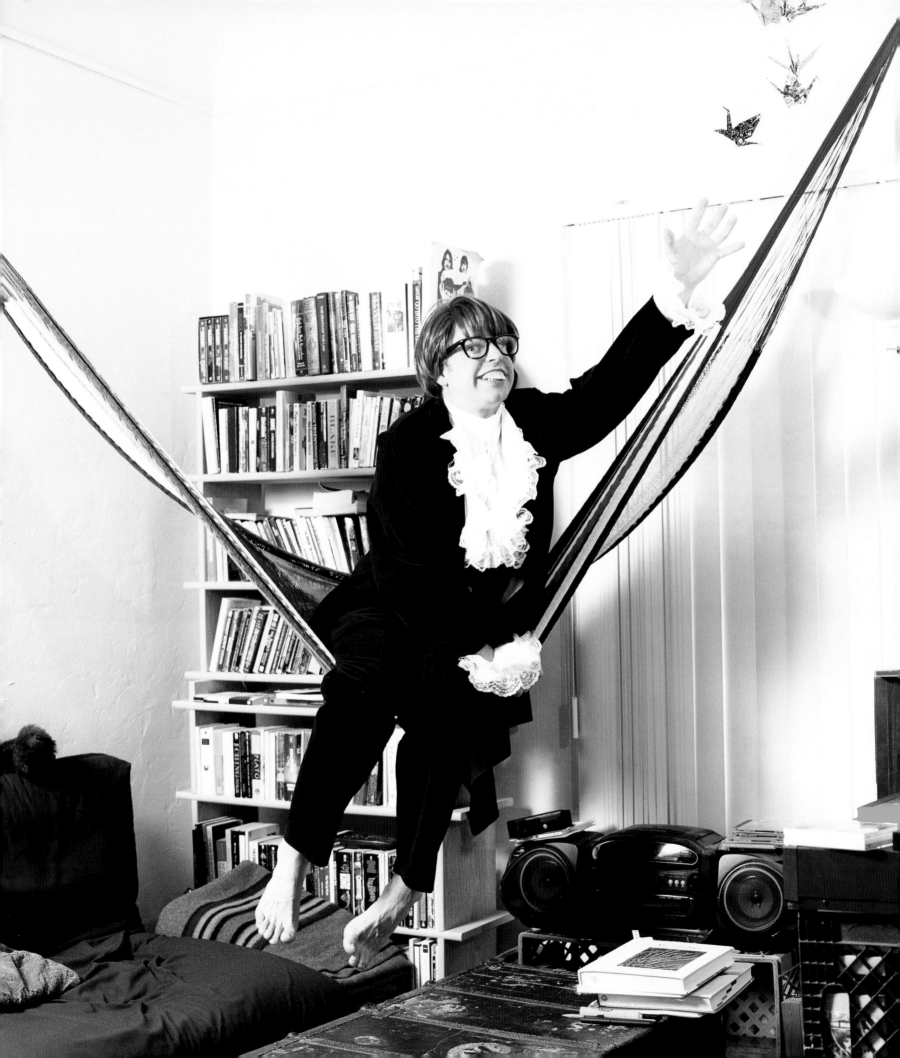

JIMI HENDRIX by Gil Gex

« Richie Blackmore of Deep Purple is my hero. »

Last jobs: Construction, bartender, actor.

Costume: My girlfriend made it in 1985 to look like the one Jimi wore at the Monterey Pop festival.

Best part of the job: A rock star requires the least amount of acting skill out on the Boulevard. I simply strike a pose and people go nuts.

Secret weapon: I do a Hendrix move, like throwing my hand up, and people start yelling "Jimi"!

Most memorable experience on Boulevard: This Bono-looking dude comes up to me and asks for a picture. I tell him his costume is really cool. He thanks me and walks away. Then someone tells me that it was really Bono. Man, I was so pissed I didn't know he was really Bono.

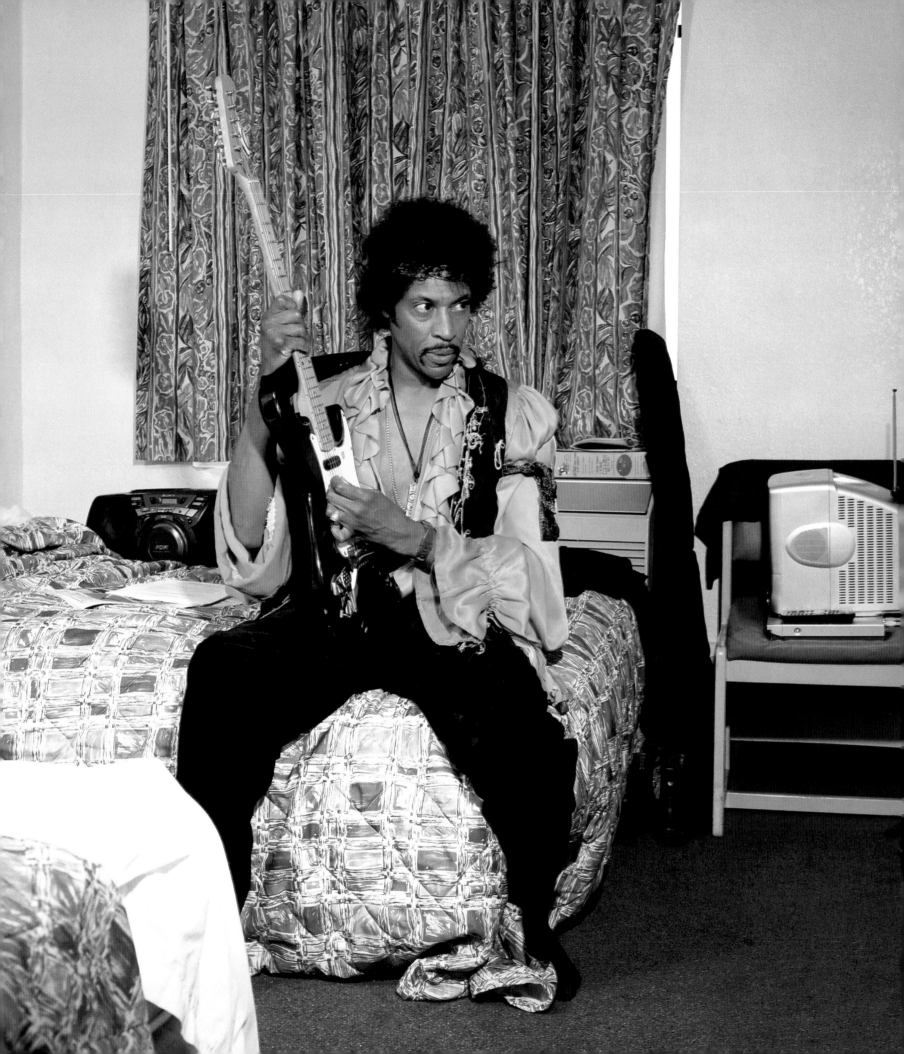

MAE WEST by Shelly Johnston

Jim's Blurb:

Thinking back on the photo shoot with Mae West, I remember the heat. We were up in her attic, which smelled like old, dry dog. It was so hot that when I moved around, it seemed like everything in that attic stuck to my body. She inherited the house from her aunt and was living with her husband. She really loved Mae West.

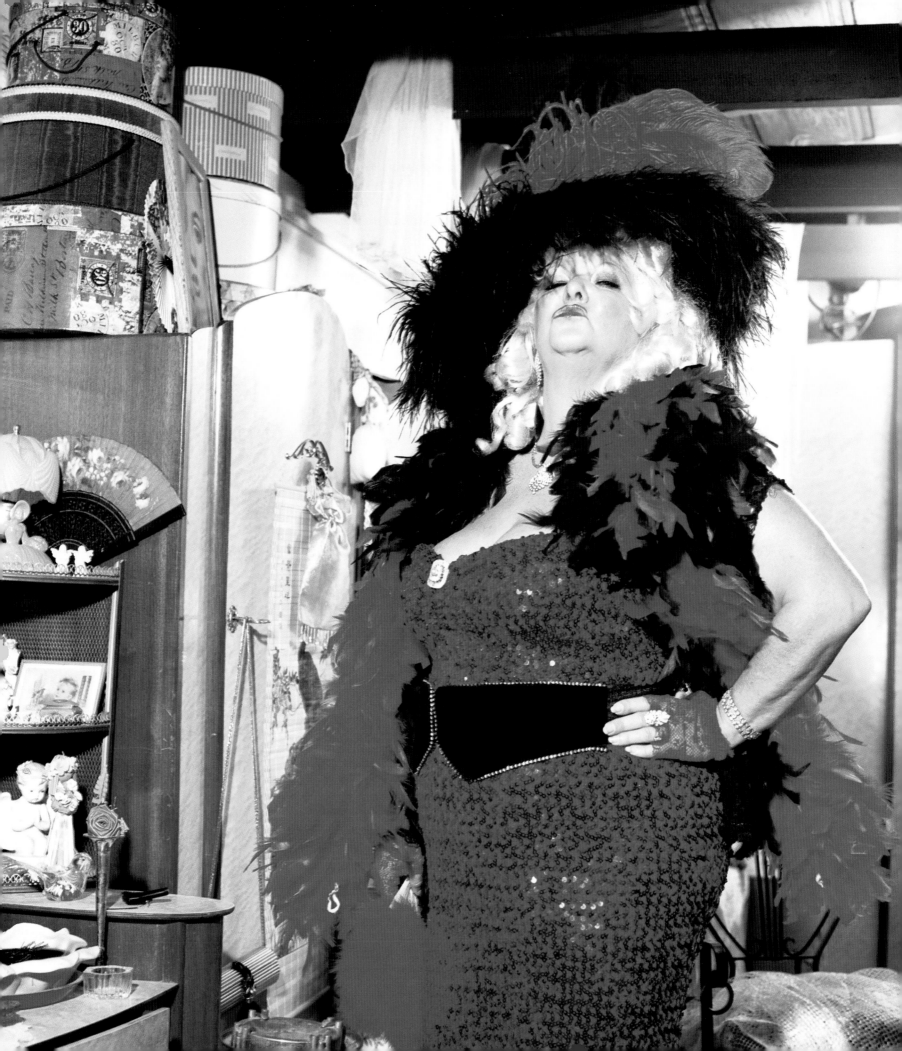

LUCILLE BALL by Arlene Parness

« *A regular job is totally depressing for me. This job makes me happy.* »

Age: It's nobody's business how old a lady is.

Last job: I was a waitress, but only lasted one hour.

Best part of the job: Having fun and making people laugh. She's the most popular dead actress. And I love the tips.

Worst part of the job: Not making tips after you've gotten dressed-up and made an effort to come out on the Boulevard.

Secret weapons: Sometimes I cry loud when I only get a dollar.

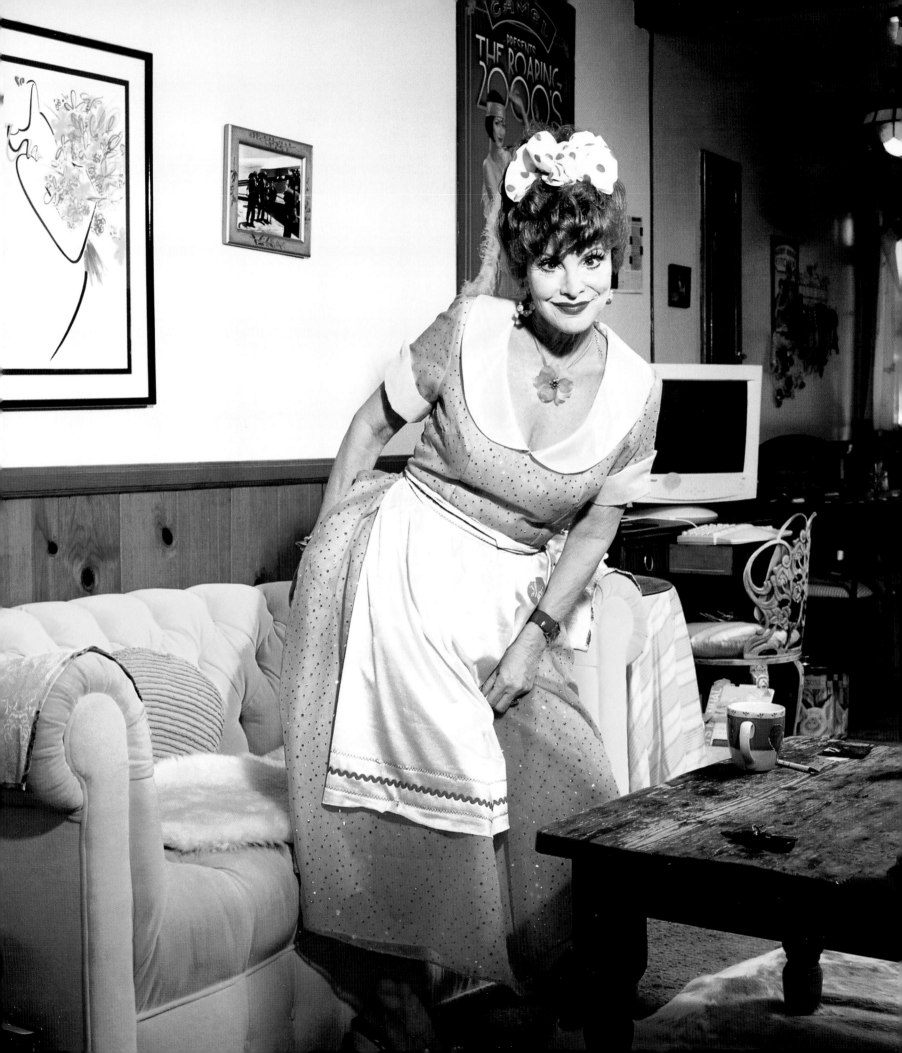

MARILYN MONROE by Melissa Weiss

« *I breathe, think, dress, move and talk like Marilyn Monroe. We have the same measurements. I become her.* »

Other jobs: I am an actress and I write screenplays. I also have my own cable show.

Costume: This is the dress from *7 Year Itch*. I got it on Hollywood Boulevard for $100 bucks.

Best part of the job: I like the people and all the different cultures. I can set my own hours and I don't have to pay income tax. And I like people taking my picture all day: *click click click*—I love it!

Favorite Imposter: Superman is so protective of me; he's like a big brother to me.

Film credits: "Nazi Freuline" in *Timecop 2*.

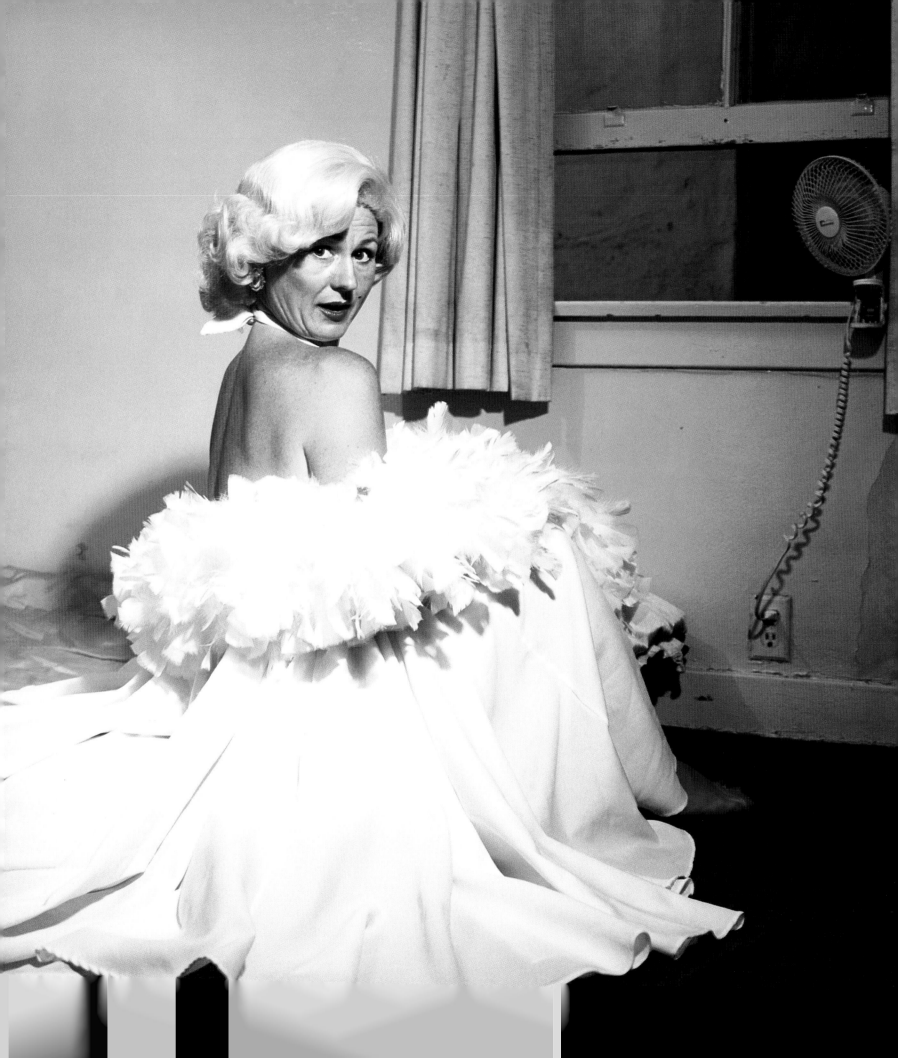

SNOW WHITE by Lidia Anfinogenova

« *I like to be a tourist and go to Disneyland.* »

Hometown: Krasnoyarisk, Russia.

Last jobs: Waitress and model.

Worst part of the job: When guys will touch me too much and I have to ask them to leave me alone.

Secret weapon: I will act like I am made of wax and then move when someone touches me.

Favorite place on the Boulevard: I like "The Last Supper" display in the Hollywood Wax Museum, but the wax museums in Russia are much better.

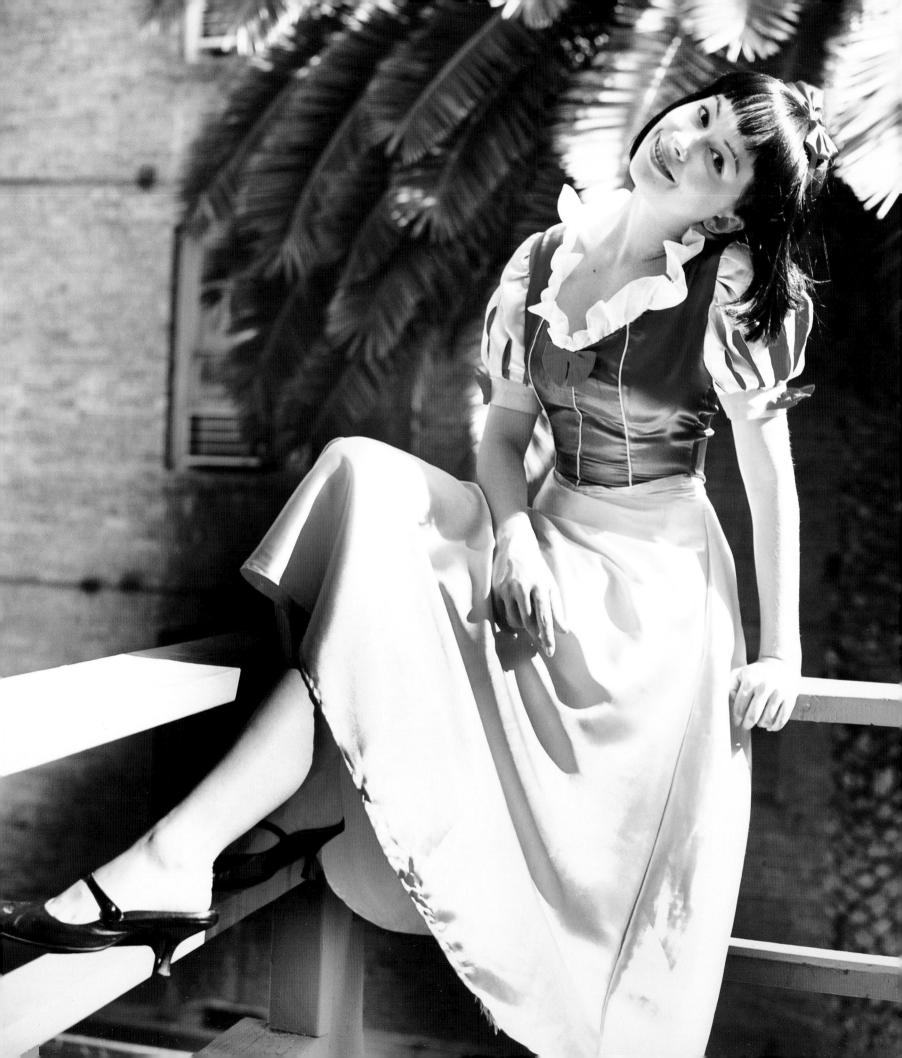

THE CAT IN THE HAT by Tony Tomey

« It's hard to eat with my nosepiece on, so I sort of starve myself all day long. »

Last job: Portraying Captain America.

Reason for changing character: Didn't make enough money.

Costume: The cat make-up takes about an hour, and I have to buy fake eyelashes once a week.

Worst experience on Boulevard: Teenagers knocking off the hat.

Average workday: 8 hours.

Other experience: Member of SAG and ASE certified mechanic.

Favorite Imposters: Batman, Superman, and Bugs Bunny.

Imposter fantasy: Having sex in the costume.

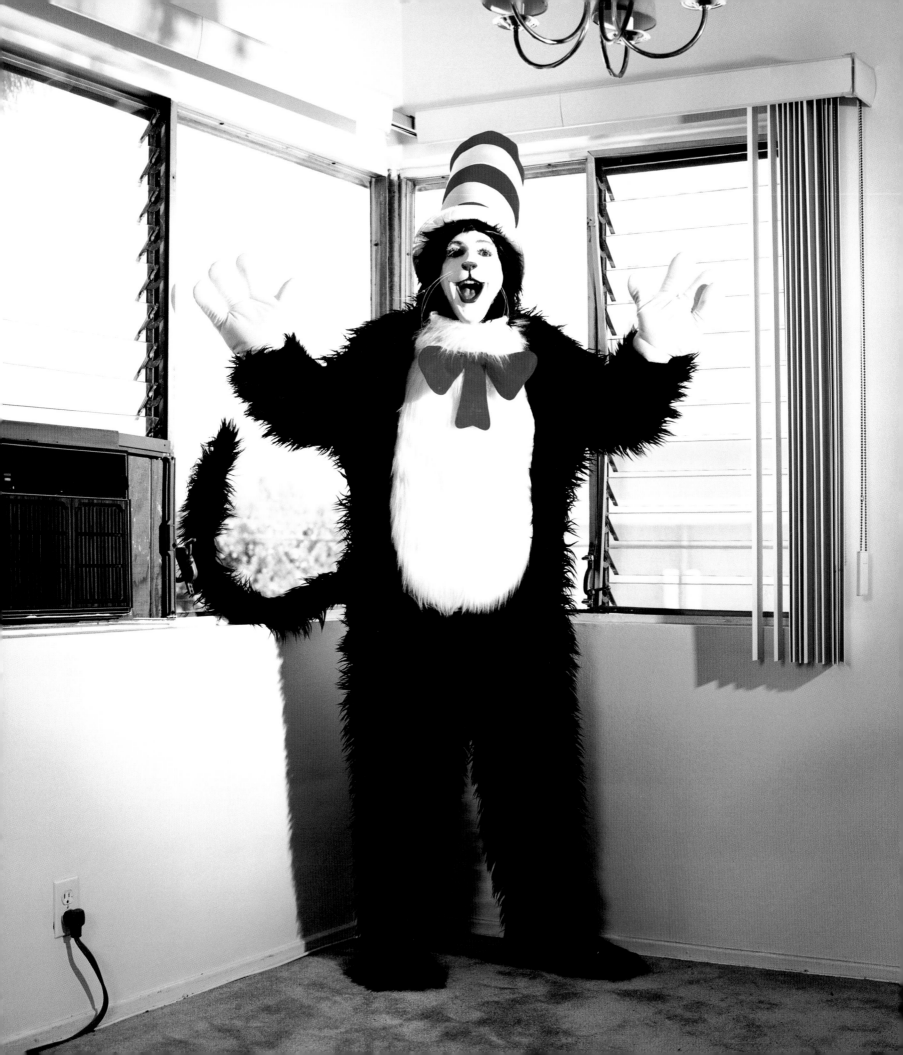

BUGS BUNNY by "John"

Last job: Army.

Costume: A friend of mine bought it for me online.

Best part of the job: Meeting the kids.

Worst part of the job: Standing outside in the heat.

Secret weapon: I do a good Bugs impression with my voice.

Current position: Only did Bugs for a year, now working in health care.

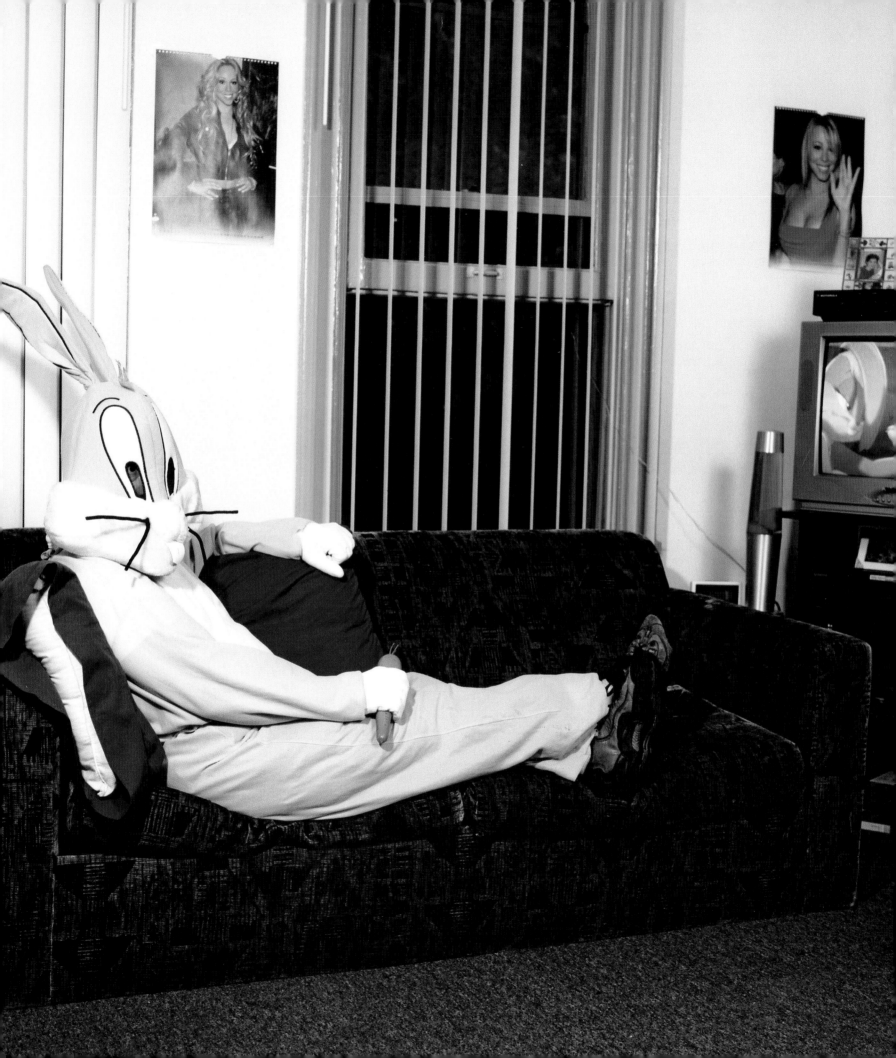

PRINCESS FIONA by Abigail Stone

« *There is a "green-breast fetish" among men. Men ask me how much of a tip would I want if they could bury their face in my breasts.* »

Best part of job: It's a great ego boost to always hear, "You're so beautiful, you look great."

Worst part of job: It gets so hot that I have to go into an air-conditioned room every ten minutes. It also is a full-body workout to constantly be bending down for photos.

Other experience: I am a filmmaker and have a degree in child development.

Advice for future Imposters: Keep your costume clean; don't swear in front of tourists; don't start fist-fights; if a child is scared, make them un-scared by taking-off your mask.

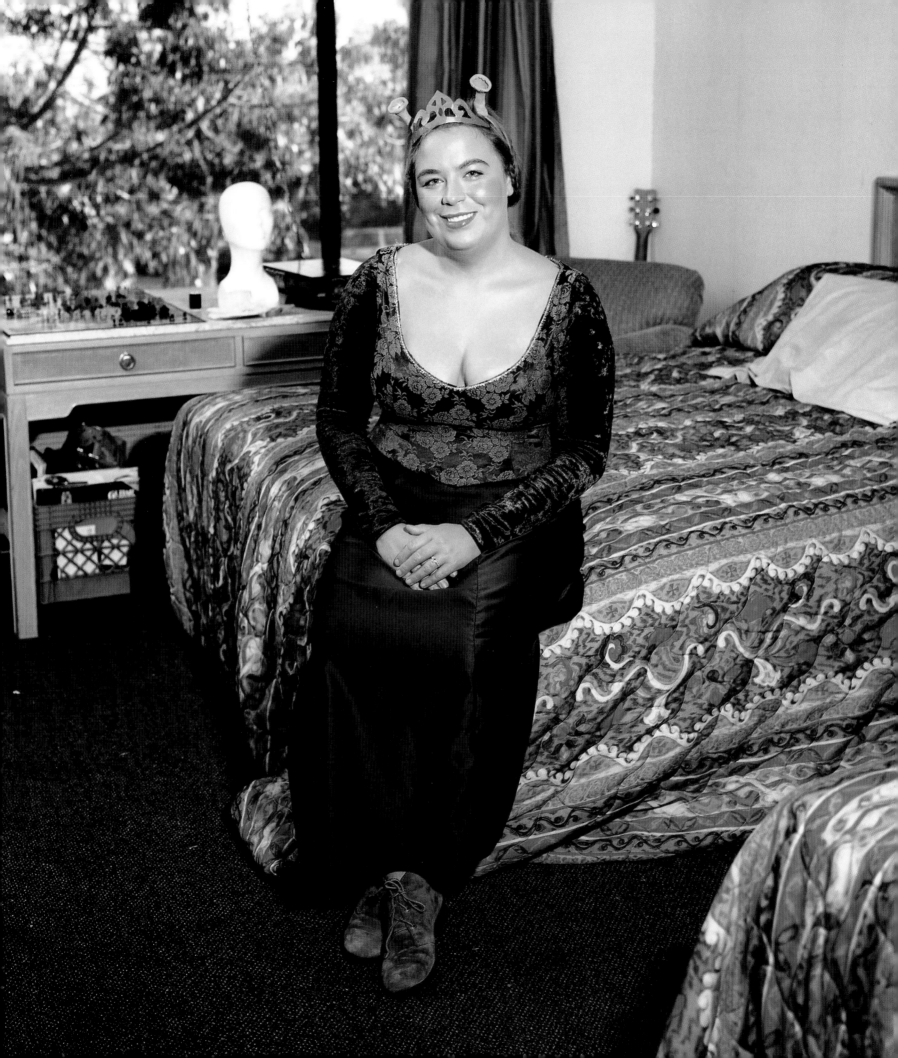

SHREK by Omar Buehoo

« I like to dance a lot—all kinds. »

Age: 36.

Hometown: NY & Virgin Islands.

Last Job: Stand-up comic.

Other job: Installing carpet.

Costume: I bought the biggest white thermals I could find and sewed them together, made some adjustments, and bought the mask.

Best part of the job: Making kids laugh or hearing them say "I love you," even though you're the character.

Worst part of the job: People who promise to tip and they don't, or people who call you names and try to make you feel bad about yourself. People being mean.

Secret weapon: My big belly!

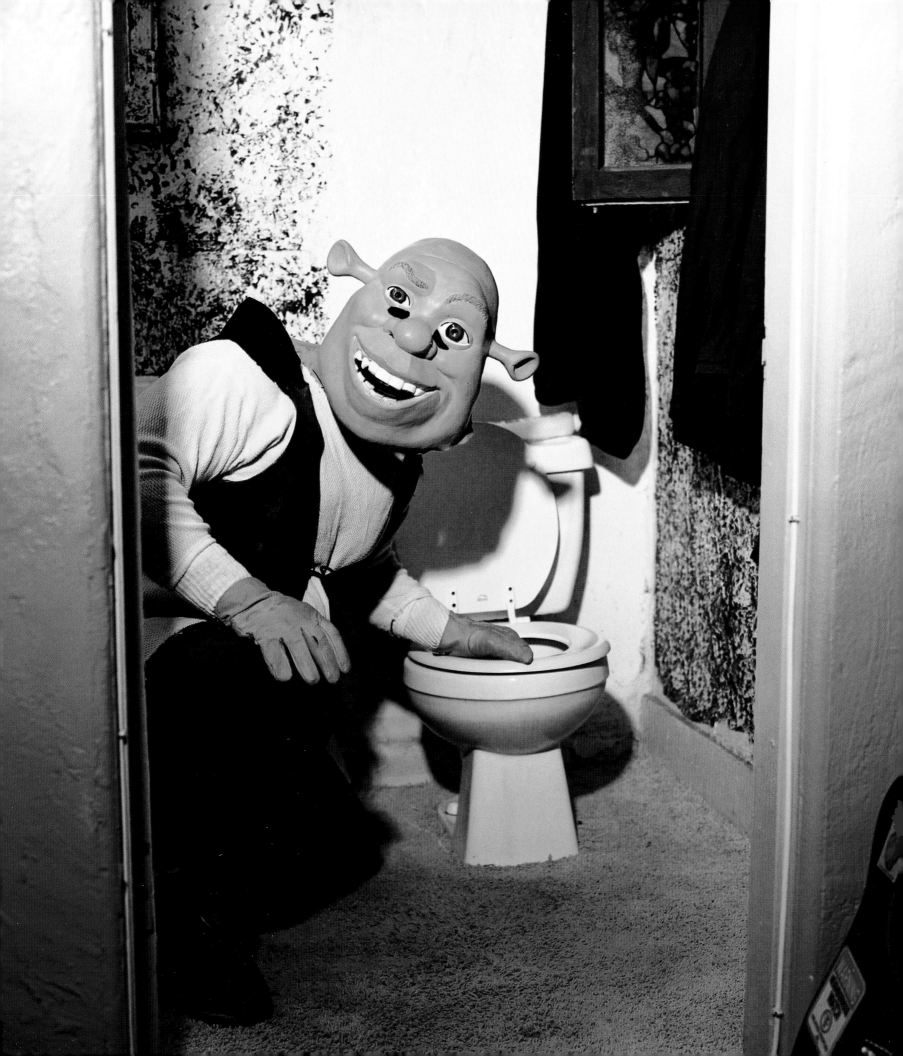

KRUSTY THE CLOWN by "Sean"

« *I hate getting harassed by the cops.* »

Last job: Selling water on the Boulevard.

Other job: I put celebrity tattoos on t-shirts.

Costume: I got the head online for $70 and I made the rest.

Best part of the job: Interacting with the tourists.

Worst part of the job: The mask gets so hot.

Secret weapon: I never talk, I just wave to people a lot and sometimes give handshakes.

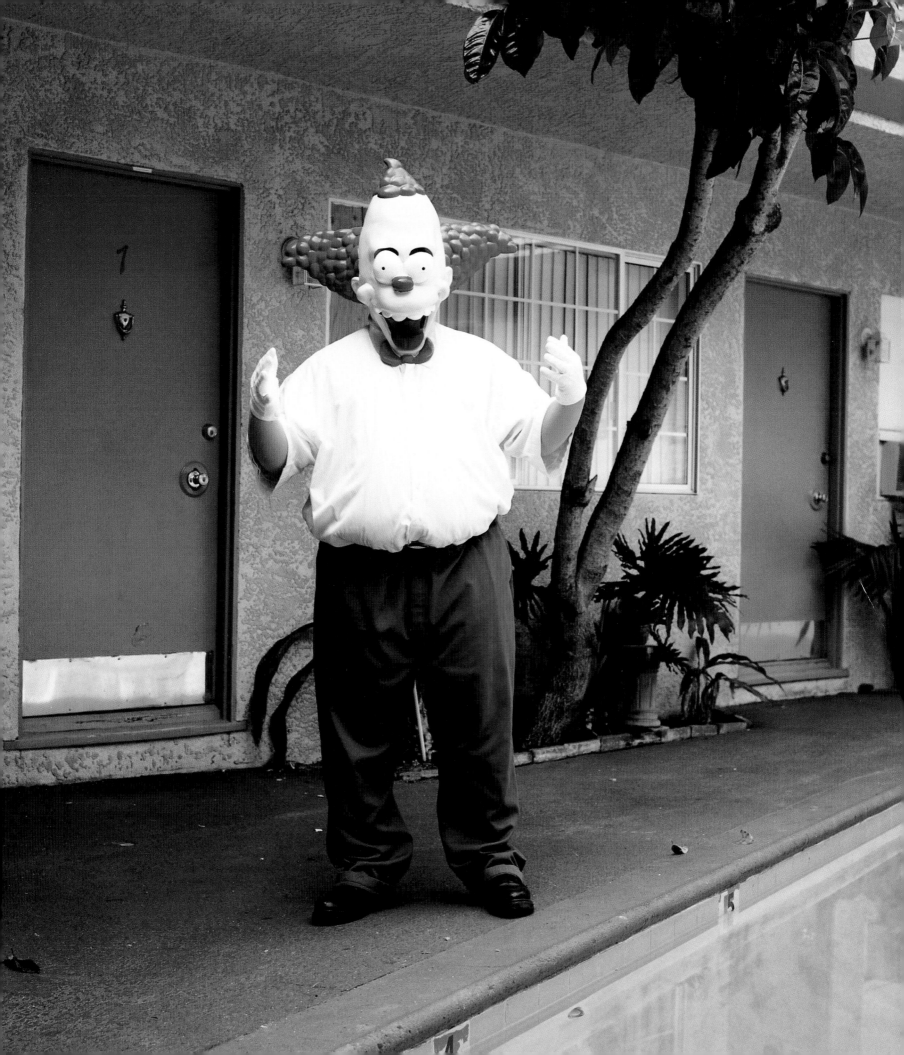

BART SIMPSON by Jeremy Ramirez

« *Had to do an internship so did this as a way to earn money.* »

Age: 20.

Education: College at Conservatory of Recording Arts & Sciences.

Other job: Freelance audio engineer.

Costume: It was a couple of sweatshirts I dyed yellow that I got from Spongebob, added a red shirt and blue shorts and latex mask.

Best part of the job: Seeing people's reactions, especially when people actually appreciated what we were doing.

Worst part of the job: The discomfort—it was hot in the summer.

Secret weapon: No one got as many compliments as I did. I used to do voices. I even played Yoda for awhile. So putting on the costume I'd get into character and just act ornery and crack jokes. My voice was better for Yoda but I didn't have that good of a Yoda costume.

Favorite Imposter: My roommate at the time was 6'2 and I was 5'3 and he would put on the Homer suit and we'd walk around Hollywood Boulevard together.

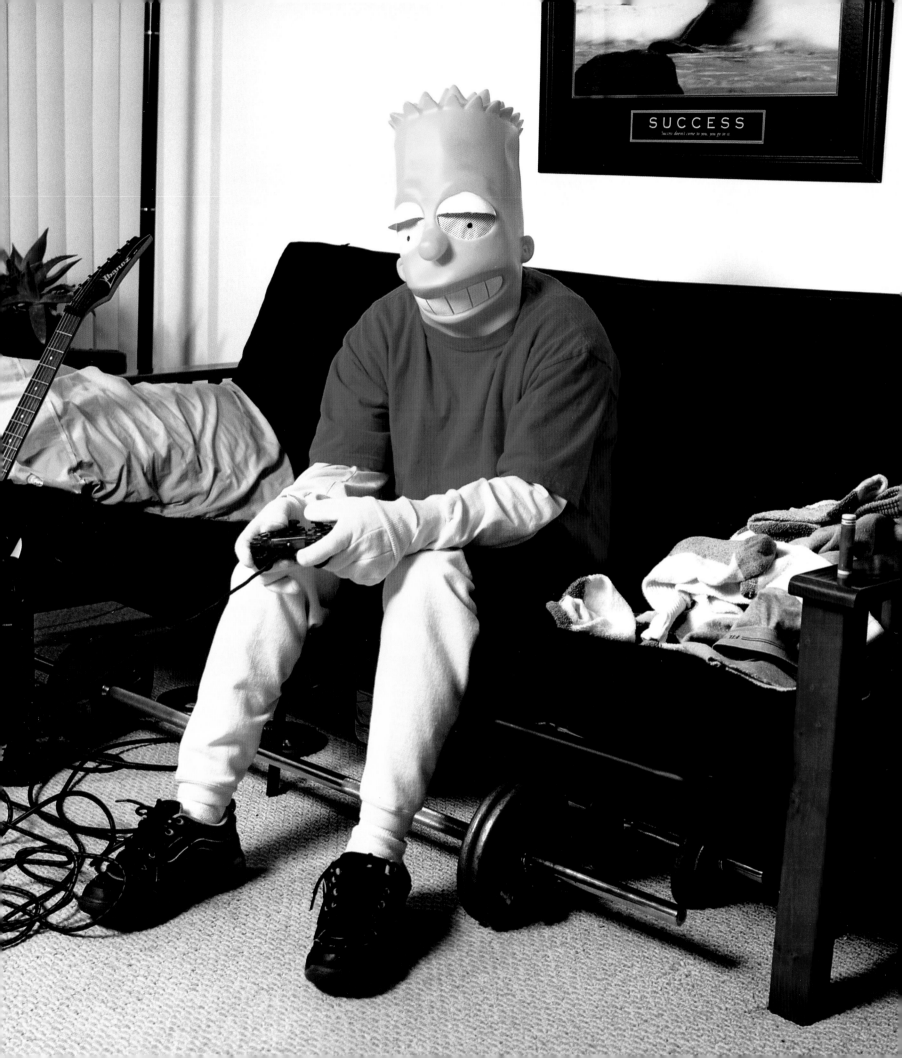

HOMER SIMPSON by Uchenda

Jim's Blurb:

Homer's studio apartment was "party central" for many of the Imposters who lived in or around the same complex. There were lots of summer BBQ parties, and consequently, many women who spent the night over at Homer's crib.

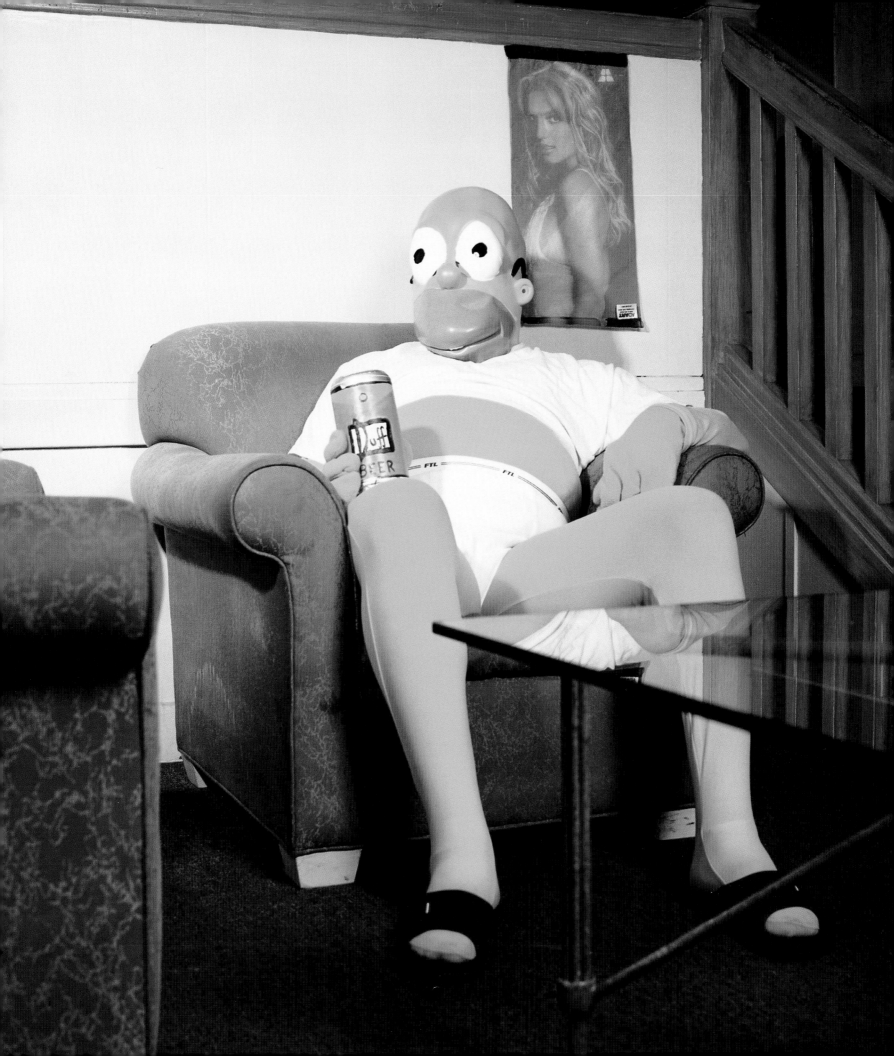

SPONGEBOB SQUAREPANTS by Don Carl Harper

« I tell every Hispanic woman she looks like Salma Hayek, every white woman Sharon Stone, and every black woman Beyonce. »

Last Job: Touring as Grimace with Ronald McDonald.

Other Jobs: Actor on the soap opera *Passions*, and mascot for celebrity children's birthday parties.

First acting job: Blaxploitation cult classic, *Monkey Hu$tle* (1976).

Best day ever on the boulevard: Over $500 in tips.

Weirdest day on the Boulevard: Batman and Bruce Lee had a fistfight that lasted about eight minutes. By the time the cops came, it was over, but a tourist taped it all. People thought it was just part of the show.

Worst Boulevard Imposter: Transvestite Catwoman from Nebraska.

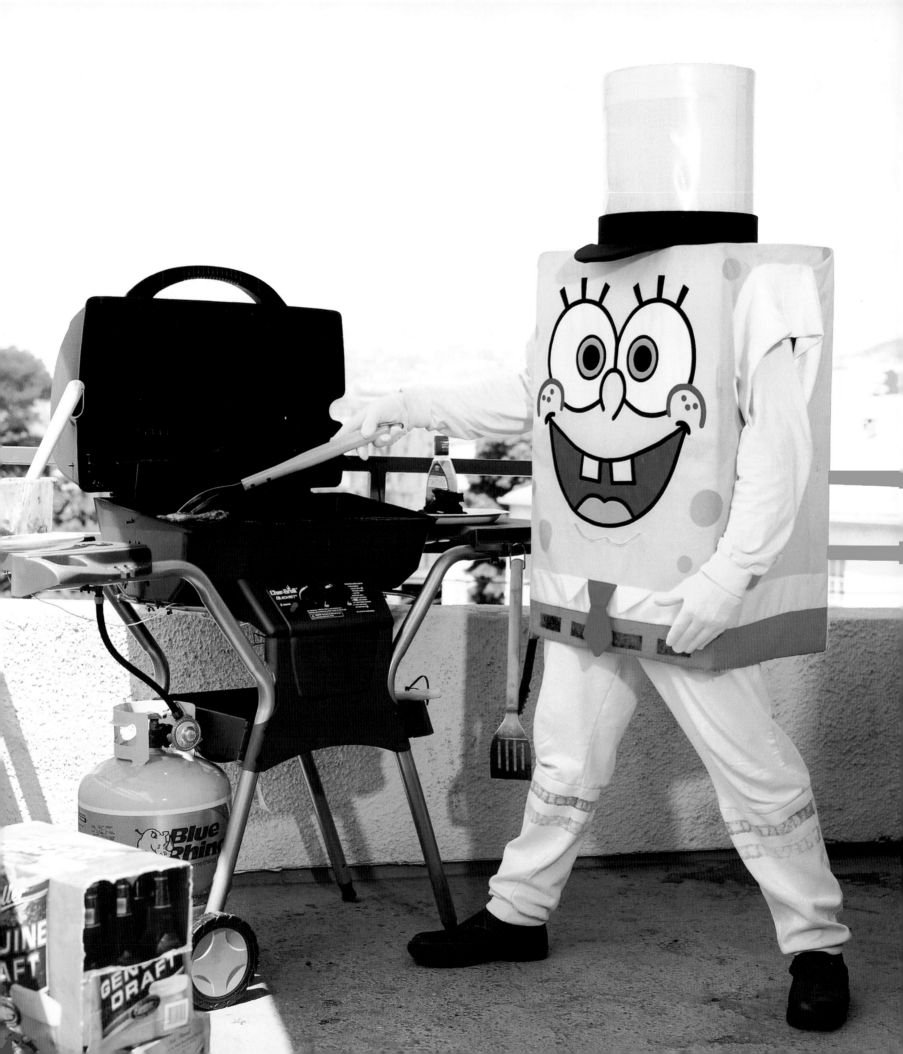

AN INTERVIEW WITH DAVID MARKEY
BY SHAWNA KENNEY

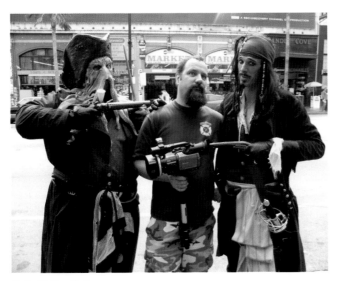

Photo © Dan Clark

David Markey is the creator/mastermind of the indie cult classics, *1991: The Year that Punk Broke*, *Desperate Teenage Lovedolls*, *Lovedolls Superstar*, and numerous music videos. His latest movie, *Reinactors: What's So Famous About Being a Star?*, follows the Imposters through the glitter and gutters of Hollywood, California. The 43-year-old Los Angeles filmmaker found out late in life that he was adopted, and says that he related to the "sadness, displacement, and the longing for identity" many of his subjects displayed during the film's year of shooting. Following is Markey's first official interview upon completion of the documentary.

Are you worried about the reactions of any of your subjects?
No. I'm sure a lot will be written about it, but I do not ridicule them and I give them their own space. Some of them hang themselves, and it's not because I tricked anybody. I mean, I didn't tell anyone what to say. I think they're fascinating people, and to me they eclipse the characters they portray and don't even know it. I feel lucky I stumbled into this world and was able to get close to them and tell their stories as a whole.

What I observed after spending so much time down there is they're really like a collection of adult children. They're all sort of battered and bruised people. They all have similar situations. They seem to be victims of child abuse or victims of something... many are estranged from their families or have mental problems. Quite a few of them are homeless. A lot have apartments very near there. Some of them do pretty well, making 4, 5, 600 dollars a day—the top earners. They're doing better than people I know. They're doing better than me! Which is great and funny. While I was making this I didn't have much money and I always tipped them meagerly for their time.

As a filmmaker, was it a hard line to walk, between telling their interesting stories without exploiting them?
I figured that out early on. There are several films floating around on the subject, but their approaches are so different than mine. I got threatening letters from lawyers of those films, which made me want to go even deeper. The film started as a short film and then it turned into a feature when I felt I stumbled onto something profound. The surface of it is obvious, but I ended up getting so much more, which compelled me to go deeper.

Did you ever consider putting on a costume yourself and trying it out?
I tried it for fun early on. I had found a *Scream* mask on the street, I wore it for about an hour. Didn't make a cent.

What initially attracted you to these people and this project?
I had seen them while driving by, and it didn't really register, until I happened to catch a news report one night that lead off the news, and it was "Freddie Kreuger Stabs a Tourist on Hollywood Boulevard!" That pulled me to it—the sensationalism. At first I thought, "Wow, movies are coming to life and attacking people. How great!" Then I thought, if you were a tourist and you were attacked by someone portraying a character for a film, what sort of psychological damage would that do to you?

Or would you just be honored?

Right! So that pulled me to it, and I went down there and was shooting for about five or six weeks before I finally met this Freddie Kreuger, because there was another Freddie Kreuger that was there in a mask, and I didn't bother approaching. I started out slow and started talking to various characters, and eventually met Gerard, the guy who was arrested, and got his story. That's when it turned into a movie. While making the film other characters started getting arrested, and the media here started using them a lot. These were lead-off news stories—various digressions leading to their arrests—and I thought, *Wow, this is news*? The media is using this. There's so much going on in the world right now. Forget the fact that no information is being given to the news, but the fact that they're using ridiculous situations like this, sort of "infotainment news." The film ended up being sort of political in a way, in that aspect, which I didn't anticipate. It's curious to me.

One of the reasons I discovered why they were getting such great footage was that Jimmy Kimmel's show is right across the street, and he has featured the characters a number of times, so every time something bad would happen, one of the characters —Chris (Superman) would call on his cell phone and they would send their camera crews out to capture these characters getting arrested. They're ABC, so it all went to Eyewitness News. Then the other networks would come out to get the after-story. Then it happened more and more frequently, which became crucial to the film.

Did you ever feel like any of them were doing it on purpose, for publicity?

No. A lot of the arrests were frivolous or even harassment. To me it's curious that Hollywood allows these rogues to dress as copyrighted characters and hustle tourists for a few bucks. I still don't understand why they allow it to happen. The only way they can deal with it is to punish the ones who they feel are 'behaving badly.'

There was a time while I was filming this that got so bizarre—I was convinced I was the victim of some sort of prank or performance theater troupe that was staging this play for me for the benefit of my film, because peoples' back-stories kind of spew out of them in interesting ways.

I know—because you couldn't even write some of this stuff, the personal entanglements and such.

You can't! And the ironies have ironies. And it's really funny, but also really tragic.

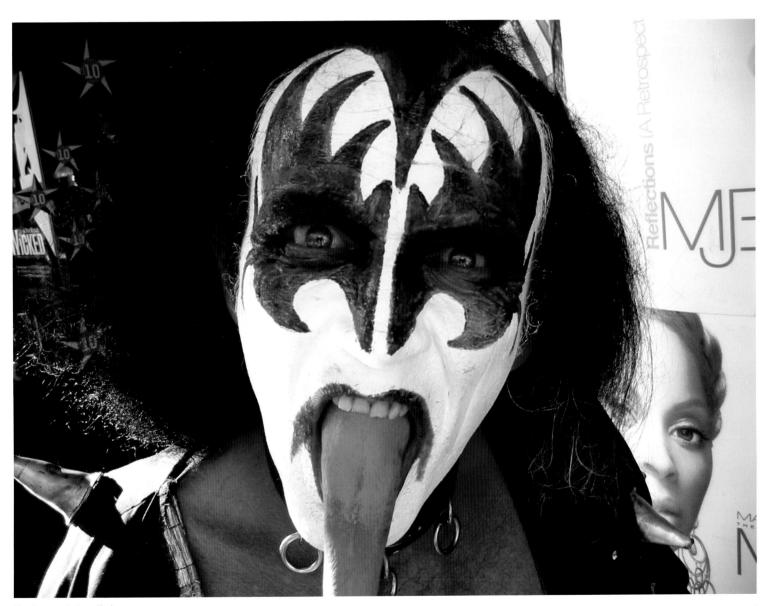

The Demon © Dan Clark

Still from *Reinactors: What's So Famous About Being a Star?* © David Markey

Do you find anything 'punk' about these people?

It's very punk rock in a way. Some of their stories, especially with Christopher, who comes across as 'the old guy on the scene.' He claims to be there 15 years, but then in the span of my interviews with him, seven months later it became 13 years. A lot of them tell tall tales, and a lot of them I don't even know if they're true, but if they're not true, that means that they're all very creative people or they're all brilliant writers. The ironic thing is, they should be writing films for Hollywood. If their life stories aren't true, then they're completely brilliant. I think it's probably a combination of the two—the whole wantonness of stardom is hardly unique, but these people embody that at such a raw, desperate level.

Isn't this a particularly "L.A. story"?

It's very L.A. It's Hollywood. The whole film is borne out of the psychotropic nature of Hollywood itself. So much of it is reminiscent of Great Depression-era Hollywood films—people coming from the Midwest to follow their dreams, to go to Hollywood to make it as a star. That plays into it pretty deeply. You have these people who believe in this 'Hollywood dream' thing, and I've lived here my whole life and know better.

These people have this innocence and naiveté about them that I've never really encountered. I've tooled around lots of art and music circles, and been around lots of strange people, and I've never met people this... entirely unique.

This goes on right across the street from the Hollywood Chamber of Commerce. Mayor Eric Garcetti said these are the crown jewels of the city. He's actually giving them a title, as rough-hewn as they are. They can't regulate it due to a loophole in Hollywood city law.

Do you think it's good for tourism?

It is, in a way, if it were regulated. I think a lot of people don't think twice about letting their children be held by some of these characters. It is very theme-park familiar, and you have to look close. I don't think people are really paying attention. They assume they're hired by the Hollywood & Highland complex. They trust that they're supposed to be there, without looking closer.

Also the relationship between them and the tourists. I wonder what that says about America's obsession with celebrity?

Some of these characters have costumes that aren't washed—they smell. The Chewbacca character who was accused of groping the Marilyn Monroe in the media recently—I don't even believe it because one of the Marilyns, I know she has serious mental issues and has had something against that character, so she may have set it up.

I don't understand how there hasn't been bloodshed yet. I think that's coming. I'm glad I got out when I did. The drama's always unfolding down there. The story goes on.

ABOUT THE AUTHORS

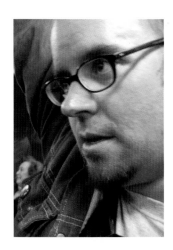

James Knoblauch has a B.A. from Temple University and went on to earn a B.F.A. from the California Institute of the Arts. His work has shown at Gallery 1988 in Los Angeles and Antagonist Art Movement in New York City. For more info see: www.jamesknoblauch.com.

Thanks to Mom, Dad and Makeda Best.

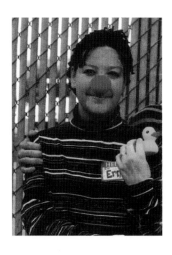

Shawna Kenney is a freelance writer and author of the award-winning memoir, *I Was a Teenage Dominatrix* (Last Gasp). Her latest essays appear in the anthologies *My First Time: A Collection of First Punk Show Stories* (AK Press) and *Without a Net: the Female Experience of Growing Up Working Class* (Seal Press). She holds a B.A. in Communications from The American University and an MFA in Creative Writing from the University of North Carolina Wilmington. For more info see: www.shawnakenney.com.

Many thanks to Roger Gastman and Buzz Poole, for finally making this happen and being so cool to work with. Also to Harriette Wimms, The Hollidays, Pam Gendell, Shira Tarrant, the Herbivore Crew, Adrienne Vrettos, Annie & Steve, John Staton, Pleasant Gehman, Dito Montiel, Eddie Nervo, Carrie Dolce, Michelle Tea, Clint Catalyst, Ian MacKaye, Greg & Shanti, Wendy Brenner, David Gessner, Bekki Lee, Melissa Kenney, the Rebel Books Stitch-n-Bitch Crew, Monika Winters-Sanchez, Jeff Sanchez, and all of the artists featured here—you are my everyday super(s)heroes. Above all, infinite gratitude goes to Rich Dolinger, the vegan man-of-steel who puts up with my many quirks and obsessions.

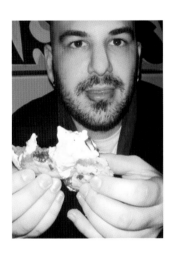

Roger Gastman grew up on the rough streets of Bethesda, Maryland, where he picked up many bad habits, like hanging outside of the Tastee Diner in a $2 CVS Batman costume begging for change with his sidekick Harley the Dangerous. Since then, he's turned his life around and kicked most of those habits. Now you can find out all about Roger's new life in Los Angeles (where he doesn't have to beg) by checking out: Rrockenterprises.com or swidlemagazine.com.

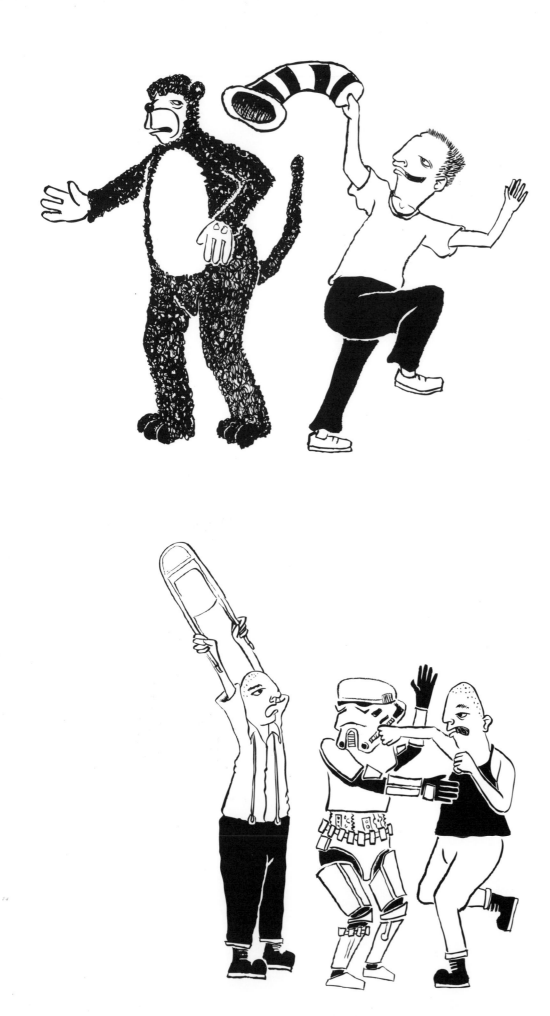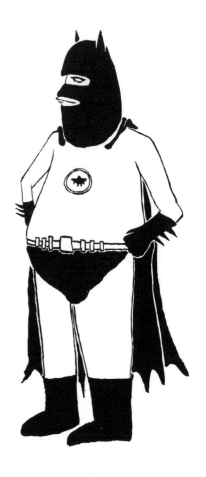